PENCIL

LAURENCE KING

First published in Great Britain in 2022
by Laurence King Publishing
an imprint of The Orion Publishing Group Ltd
Carmelite House, 50 Victoria Embankment
London EC4Y 0DZ

An Hachette UK Company

10 9 8 7 6 5 4 3 2 1

A CIP catalogue record for this book is
available from the British Library.

ISBN 978 0 85782 910 8

Origination by DL Imaging, UK
Printed in China by C&C Offset Printing Co. Ltd.

Laurence King Publishing is committed to ethical and
sustainable production. We are proud participants in
The Book Chain Project ® bookchainproject.com

**BOOK
CHAIN
PROJECT**

Front cover: Sarah Maycock, *Figs*, watercolor crayons on paper, 2010.
© 2010 Sarah Maycock
Back cover: Andrea Serio, *Terzo Round*, color pencils on paper, 2021.
© 2021 Andrea Serio

www.laurenceking.com
www.orionbooks.co.uk

PENCIL

Do More Art

Eve Blackwood & Selwyn Leamy

CONTENTS

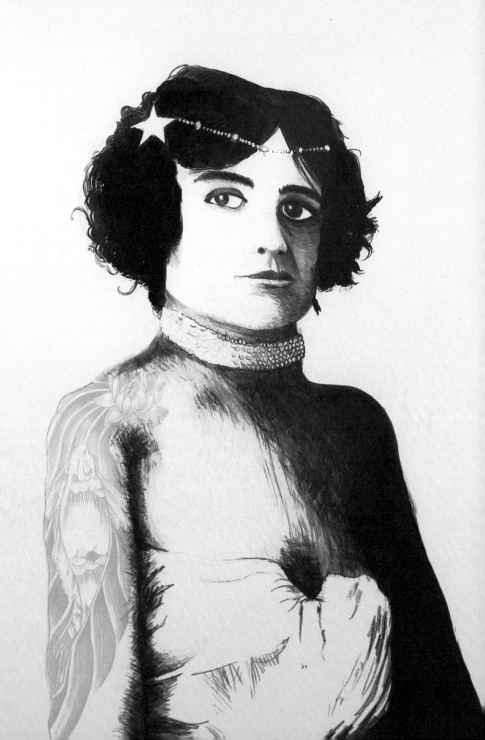

MIGHTIER THAN THE PEN

Opposite:
Eve Blackwood,
*Coy Tattooed
Lady,* Conté and
color pencil on
card, 2020

The humble pencil. It's one of the first mark makers we get to know as a child, and probably our most familiar drawing tool. But don't underestimate this workhorse of the creative world—used in the right way it can produce an incredible diversity of line, tone, texture, color, and expression.

Some pencils are creamy and glide across the paper, while others have more bite and create a varied, grainy line or give a satisfying, waxy resistance. You might choose a particular pencil not only for its mark-making ability, but also for the pleasure of applying it to the paper. Many artists will have a favorite pencil that they use because its attributes suit the way they draw.

In this book you will discover a wide variety of pencils, and a rich source of ideas of how to experiment with them to learn new techniques. Drawings from a host of different artists and illustrators will help you along the way, inspiring you to have fun and explore. With a selection of your favo rite pencils in one pocket and a sketchbook in the other, you will be amazed at what you can achieve.

WHAT CAN A PENCIL B?

The one thing you can say about any pencil is that it does not contain lead: the "lead" in "lead pencils" is actually a combination of graphite and clay. But the story doesn't begin and end with your everyday writing implement. You may be surprised at the range of pencils that are available for you to try—carbon, charcoal, and water soluble and mechanical pencils, to name but a few.

The pencils that you will probably be most familiar with are the ones we all had in our school pencil cases: H, HB, and B. Pencils are graded on the HB scale. The letter H indicates a hard pencil (more clay, less graphite); B indicates a softer lead (more graphite, less clay), increasing the blackness of the pencil's mark.

If you go into an art shop, you will be faced with an array of graphite pencil sets, ranging in price from suspiciously cheap to crazily expensive. If you don't want a set, you can buy pencils individually, which will allow you to choose from the upper end of your price bracket without breaking the bank.

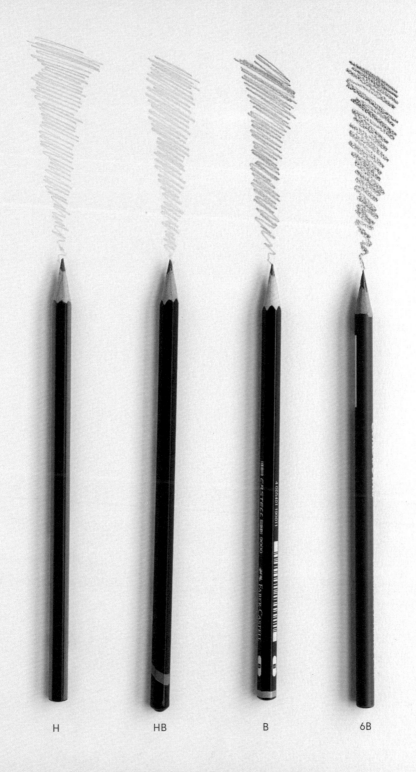

H HB B 6B

GET TO KNOW YOUR PENCILS

6B
One of the softest pencils out there. It will give you a powerful black line when you press down hard. Working lightly with a 6B will give you a softer line, but because it is so soft it gets blunt quickly and won't give you the same precision as a harder pencil.

2B
A versatile pencil great for quick sketches. It is soft enough to still give a rich, dark line when you press hard, but it stays sharper longer than the 6B. Less pressure produces lighter lines that still retain a subtle depth.

HB
Not too hard and not too soft. It will produce a decent dark line when you press hard, but not as rich as the Bs. Less pressure gives lighter lines that are less grainy, which can be good for more delicate drawings.

H
Very hard, so it will stay sharp for ages. This is not the pencil to give you a dark tone. Even if you press hard you will still get quite a light line, but the pencil will leave a deep indent in the surface of the paper. Less pressure will give a very light line, beautifully sharp and precise.

Some other equipment you might need:

Eraser
A good-quality soft eraser is essential for removing unwanted pencil marks from paper.

Fixative
Fixative is sprayed over finished artwork to stop it from smudging, essential for soft pencil drawings. A cheap can of hairspray often works just as well.

Mechanical pencil
Mechanical pencils have built-in erasers and don't require sharpening. Their replaceable leads are measured in millimeters: a 0.7mm lead will draw a wider line than a 0.5mm will. The hardness of the leads are graded same way as regular graphite pencils. Other advantages the mechanical pencil has are a built-in eraser and a point that does not require a sharpener.

Blending stump (tortillon)
This makes the difficult job of blending much easier and cleaner.

You definitely won't need:

A ruler or a compass
They give you a uniform, dead line. You will lose any expression or artistry in your line, and interesting drawings are all about character. Unpredictability and a little wobble are a good thing.

HOLDING YOUR PENCIL

The way you hold your pencil has a big impact on how your drawing will look. Changing your grip on the pencil can change the style of your lines or marks, helping you to add character to your drawing.

Your standard writing grip (below) will give you sharp, precise, controlled lines. This is good for making the careful, deliberate, detailed, and meticulous marks you need for an analytical drawing that will explore, sharpen, refine, and crystallize your understanding of your subject.

Holding your pencil loosely (opposite top), so that the side rather than the point of the lead makes contact with the paper, will allow you to make free, instinctive marks—sketchy, impulsive, loose, evocative, or sweeping.

Holding your pencil in a sideways grip (opposite below) will allow you to angle the lead so that the whole edge of the lead rather than just the tip is in contact with the paper. This produces a wide mark, which is good for shading and laying down tone.

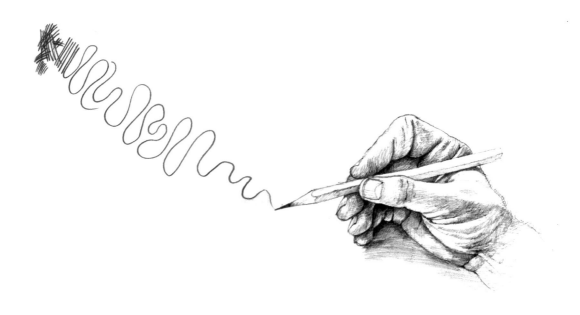

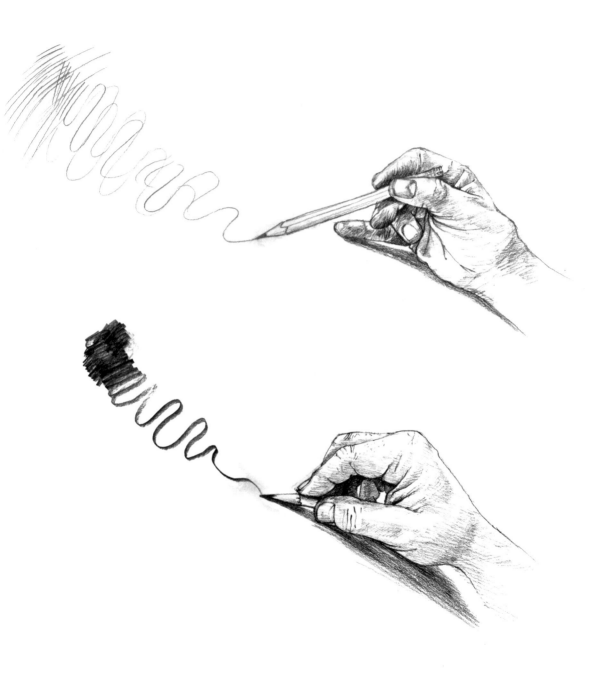

PAPERS

There are lots of different papers, from budget photocopy paper to thick watercolor paper. When choosing paper, the main things to think about are weight and surface.

Paper comes in different weights. Measured in grams per square meter (gsm), which describes how thick or thin it is, it ranges from 80gsm (photocopy paper) to 330gsm and up (almost as thick as card). A thicker paper will take more vigorous pressure and survive repeated erasing and re-working.

The surface of a paper is often described in terms of "tooth." Rough paper has more tooth, which simply means it is bumpier and gives more resistance when you draw on it, creating a grainier line.

Cartridge paper
Standard drawing paper, with surfaces ranging from very smooth to rough. A standard sketchbook usually contains 140gsm cartridge paper with a medium tooth. Smooth white cartridge paper is good for bold, graphic drawing with a clarity of line.

Watercolour paper
This is heavier paper designed for use with watercolors and other liquid media, as it will not buckle. The roughest types have a lot of tooth, which will give your drawings texture.

Other papers
Tracing paper and colo red or tonal paper can help you achieve different effects in your drawing (see pages 104-109).

A FEW USEFUL TECH- NIQUES

EXPERIMENT WITH PRESSURE

Different pencils will give you different marks, but a key component in your mark making, whichever pencil you use, comes down to how hard you press when you are drawing. The amount of pressure you exert on the pencil allows you to produce a variety of marks, ranging from thicker, darker lines to more delicate, fainter lines.

If you're making a quick, dynamic drawing, you don't want to be constantly changing your pencil, so choose one that can give you a range of marks. Then, while you're working, you can vary the pressure of your marks, pressing harder for a heavier, more definite line or using a lighter touch for more exploratory lines.

Even when you don't use shading, varying the darkness of the line can make your drawing more expressive, as well as communicating mood and intimacy, as in this nude study by Endre Penovác.

TRY IT YOURSELF

Vary the pressure
As you draw, change your line from fine to bold by adjusting your pressure on the pencil point.

Tilt your hand
Try alternating between the point and the side of the pencil lead to vary the thickness of your line.

Suggest texture
Contrast a bold confident line with a scribbly line to suggest texture.

Start light
You can start by drawing with light lines and then revisit with a darker mark.

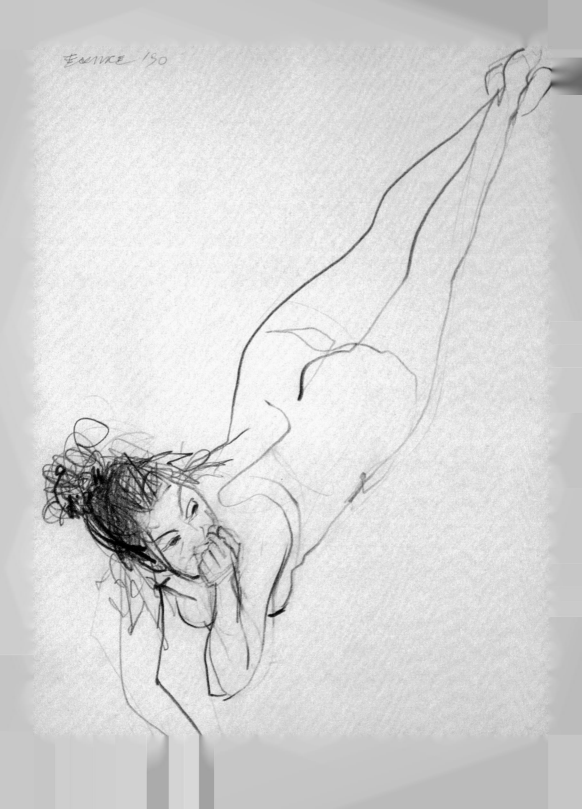

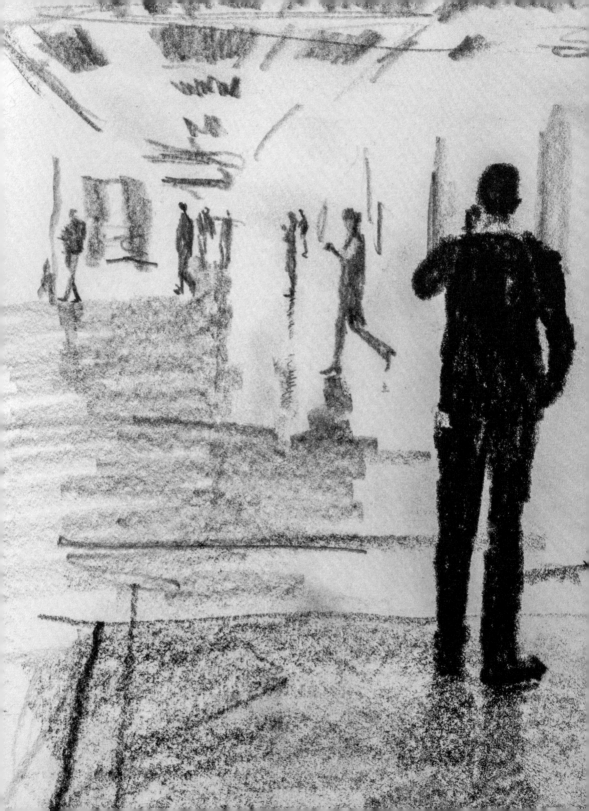

USE TONE INSTEAD OF LINE

Opposite:
Massimo
Rossetti, *Untitled
#J003*, graphite
on notebook
paper, 2008

Tone adds light and darkness to your drawings—this is called shading. You can use shading to give a three-dimensional effect or create atmosphere and mood. You can vary the tone of your shading: these different levels of tone are usually described as light, mid, and dark. Try using tone rather than outlines to create an image.

Here Massimo Rossetti uses tone to create a sense of space and environment. The figures are drawn in a quick, sketchy style without outlines, giving an impression but no fine detail, and the shiny surface of the floor has been created with the side of a pencil. The figure in the foreground has been drawn in the same sketchy, blocky style but using much heavier marks to create a darker tone.

TRY IT YOURSELF

1. If you're drawing from life, squint your eyes to view your subject without detail.

2. Use the side of your pencil to create blocks of tone. Start by filling in the darkest areas first, then work towards the lighter parts.

3. Where there are highlights, leave the paper white. Everything else should have tone on it.

Tip Spraying fixative (or hairspray) onto your finished drawing will keep big tonal blocks of graphite or charcoal pencil from smudging.

HATCHING

Opposite: Brenda Holtam, *Oscar*, pencil on paper, 2020

Hatching is another technique for adding tone to a drawing. It involves laying down parallel lines or marks, made with the tip of your pencil. These lines can go in any direction you want, but they're often diagonal because that's usually the easiest direction for your hand to go. To adjust the intensity of your tone, how light or dark you want your shading to be, there are two things you can do: vary the pressure on your pencil to make your hatching lighter or darker, or draw the hatching marks closer together or further apart.

This sketch by Brenda Holtam is a wonderful example of how shading can bring a drawing to life. The contours of the model's head are built up with blocks of gentle hatching. Notice how she covers the whole of the face with a light tone, only leaving the paper blank for the small highlights.

TRY IT YOURSELF

1. Starting by lightly laying down some hatching lines to form a basic visual map of the object.

2. Then refine this map by building up the mid tones and the darkest areas with more confident marks, leaving parts of the paper clean where the highlights would be (or erasing the hatching in these areas). To create the darkest shadows, press harder with your pencil or pack your hatching lines more densely together.

3. Finally, add some small details to describe particular features of the object or person.

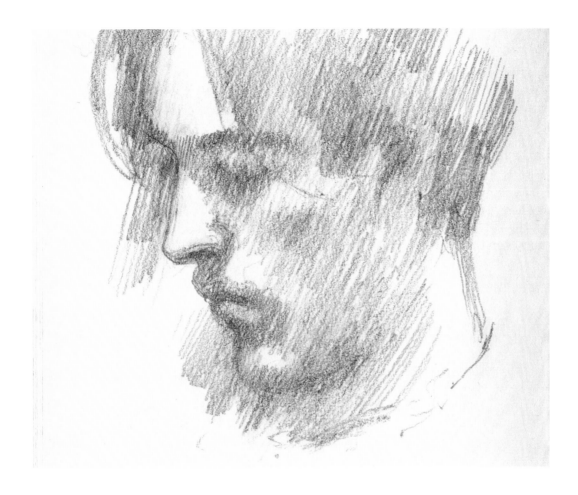

Here hatching is used to build up the body and variations of tone in the hair.

Notice how an area of the same tonal value can look darker when contrasted with the white of the unmarked paper.

CROSS-HATCHING

Cross-hatching takes hatching one step further, cutting across one series of lines with another that runs in a different direction. This technique can give you rich darks by building up the layers of graphite, and can make it easier to achieve a greater range of grays than you can with hatching alone. The different directions of the marks can also help you describe the shape of the object you're drawing and add texture to it. The lines and marks do not have to be neat or smart, they can be just as effective if they are loose and rough.

In *Park Bench*, the outline of the scene was drawn first, then the tone was built up with cross-hatching, paying particular attention to the shape of the bench and texture of the bushes around it.

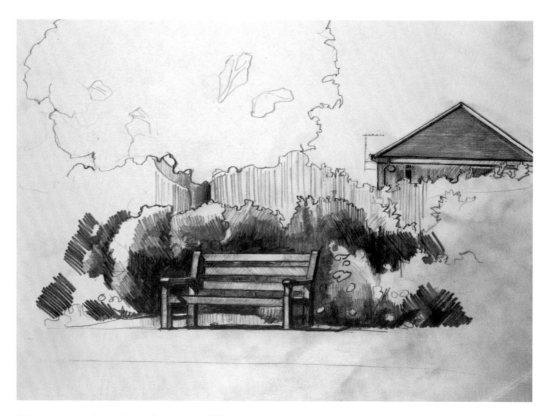

Selwyn Leamy, *Park Bench*, pencil on paper, 2020

1. Draw the outlines of an object lightly with a sharp pencil.

2. Look carefully at the scene and think about what kind of texture and form you need to build up. For example, you might use long, smooth lines for a flat area, or groups of short lines in a variety of directions for a spiky bush.

3. Start with a hatched mid tone, leaving the highlights blank.

4. Layer your lines with cross-hatching to make the darker tones.

EXPLORE NEGATIVE SPACE

Negative spaces are the areas around the object you are trying to draw. Looking at these spaces and the gaps in between your subject can help you make sense of it. Use bold areas of tone to fill in the deep shadows and then work outwards, filling in the mid tones using hatching and cross-hatching to create a variety of shades.

By using this technique Rachel Mercer works logically through the tangled complexity of these leaves and stems, creating a realistic drawing that also captures the rhythms and patterns of the plants. This technique may take you in a different direction, perhaps producing an abstracted drawing that is based on the patterns and shapes of your subject rather than an accurate depiction of reality.

TRY IT YOURSELF

1. Start with a small area, and describe the dark shadows using solid tone. Work outwards from that point and build up areas of shading in the mid tones.

2. Outlines will help you to make sense of the subject, but don't be tempted to sketch too much in too quickly or you might lose your place.

Opposite:
Rachel Mercer,
Pea Plant, pencil
on paper, 2014

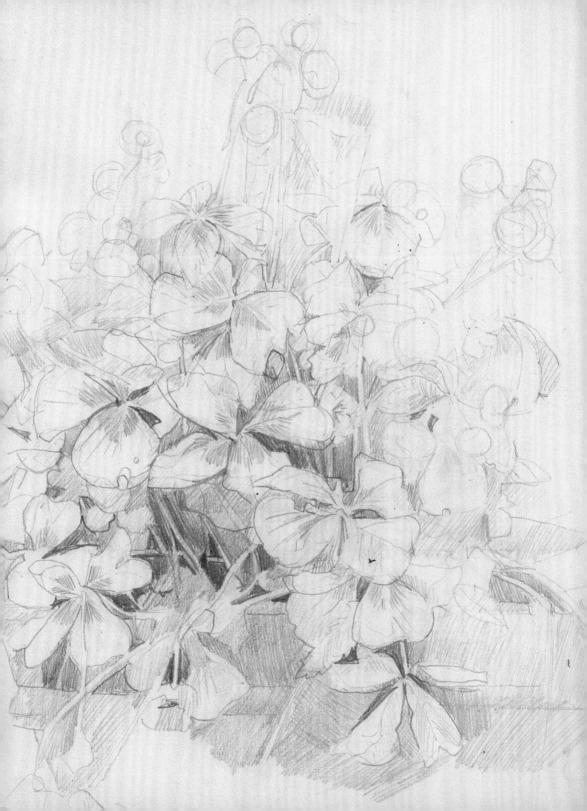

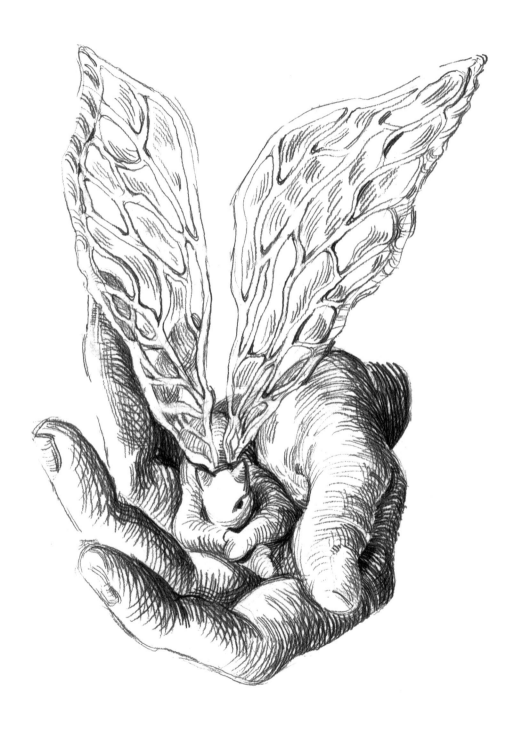

BRACELET SHADING

Opposite:
Lily Vie, *Small Angel*, graphite pencil on paper, 2020

Bracelet shading is like hatching and cross-hatching, but the lines are curved rather than straight in order to wrap around the form of the shape. When using bracelet shading, the lines should describe the curved surface of the object—imagine a bracelet circling an arm. The advantage of this method over straight hatching is that you will not only be adding tone but also describing the form of the object in front of you. Lily Vie uses this technique to capture a hand cupping a figure.

TRY IT YOURSELF

1. Draw the outlines of the object lightly with a sharp pencil.

2. Following the curves of the object, start in the darkest parts, shading using curved lines.

3. Layer up your curved lines to make the tone darker (as with cross-hatching).

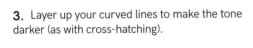

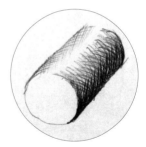

STIPPLING

Stippling is simply creating tone with dots. As with hatching, darker areas can be created by grouping the dots closer together or pressing harder to make a darker mark, and also by making the dots larger. You can use any combination of small marks in this technique. These marks can also give information about the surface of your subject: for instance, short dashes could represent grass.

Taking stippling further and making repeated marks or lines can add texture and variety to your drawings. The examples on this page show how diverse this method of shading can be. Van Gogh is the master of this kind of mark making. For inspiration, have a look at some of his pencil portraits and drawings of the fields around Arles to see the huge variety of marks he uses to create texture and movement.

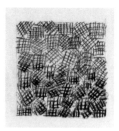 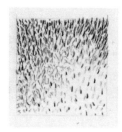 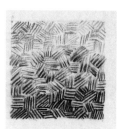 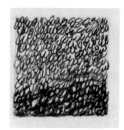

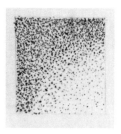 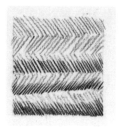 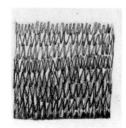 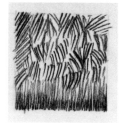

The dots, dashes, and marks you make will give you a variety of textures. You can develop your own vocabulary of marks to describe different surfaces. Here you can see how short staccato dashes can suggest stubbly grass, whereas longer curvy lines give the impression of hair or fur.

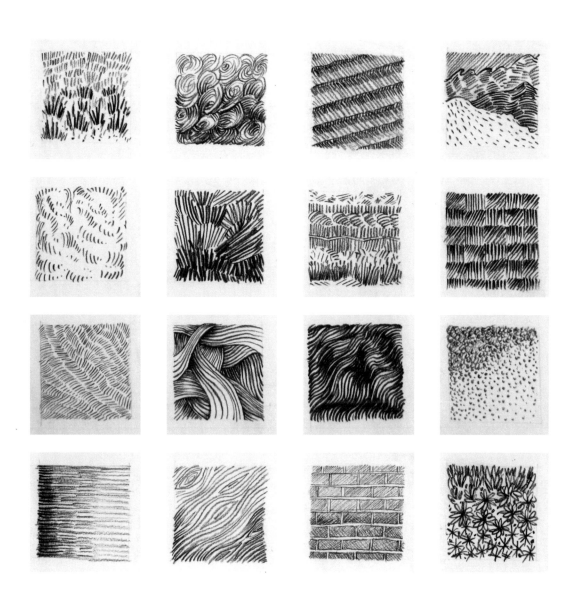

COMBINE MARKS TO CREATE TEXTURE

We have looked at a variety of ways to create shading and tone. Now we are going to think about choosing the right marks to create texture: Which direction should your lines go? How thick or thin, light or dark? When drawing, think about the different ways you can hold your pencil and varying that as you draw. For instance, the side of the lead will give you a thicker line (see page 12).

(see page 12)

TRY IT YOURSELF

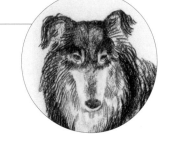

Lily Vie has used a range of marks to capture the different "feel" and look of three very different dogs. For the collie she has used a variety of directional lines: horizontal lines for the shorter hairs at the top of the head, with curved, flowing lines for the longer part of the dog's coat.

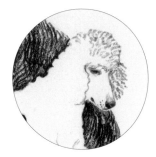

She has used a different combination of marks for the poodle. The fluffy hair at the top of the head is described with light marks made with the side of the lead, which brings out the rough surface of the paper to add to the texture of the hair. A series of scribbled lines is used to express the densely packed curls on the dog's ear. Both these marks add to the impression of the dog's coat.

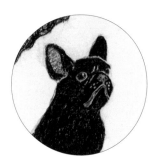

The dense, short hair of the bulldog is drawn in a block of dark tone that has very little texture. All these different lines and marks combine to express the individual textures and feel of the dogs.

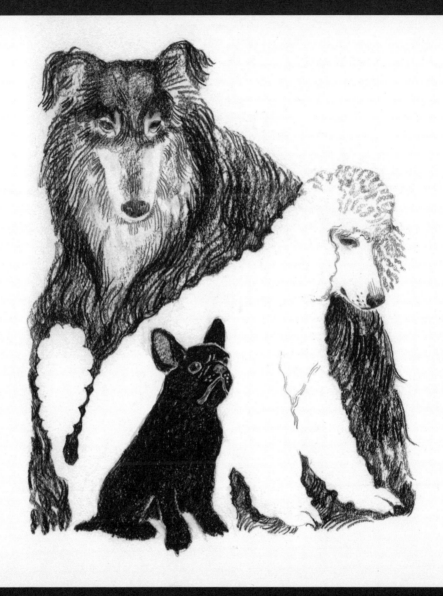

Lily Vie, *3 Dogs*, pencil and graphite stick on paper, 2020

CAPTURE THE SPIRIT OF YOUR SUBJECT

Highly realistic drawings are not the only way to depict a place or a person. When you're drawing, try to express the energy and character of your subject. Be expressive and free with your marks, and don't worry about being messy. Leave your scribbled marks visible and don't correct yourself as you work.

Peony Gent has used lines that have lots of life and energy to give a sense of the busyness and hubbub of a café. The scribbled lines of tone in the fireplace fly off in all different directions, which conveys a kind of hectic feel that ties in with the idea of a bustling café—even though here there are no people. These animated lines have a character and charm of their own.

TRY IT YOURSELF

Be carefree
Don't worry about accuracy, this is all about conveying a sense of place.

Work quickly
Keep your hand moving. If you get stuck on something, leave it and move on.

Use a variety of marks
Use pattern, lines, and directional marks to give clues about surfaces.

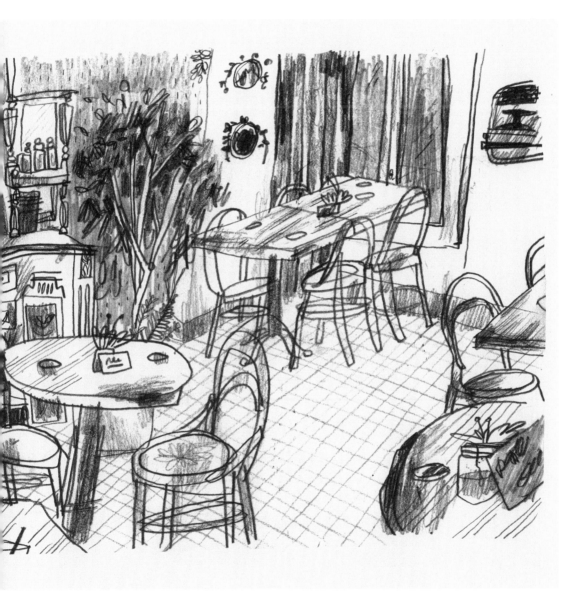

Peony Gent, *Paradise Palms*, pencil on paper, 2016

DEVELOP YOUR TONAL DRAWING

Below:
Eve Blackwood,
Rowan and Gil,
graphite and
blender, 2020

Using a tonal drawing technique can help you get to grips with a challenging subject. Like we saw before on page 20, in a tonal drawing, you start with the simplest visual impression of what you see, which is generally light and dark shapes, without detail and without heavy outlines. Squinting your eyes to soften your focus will help you to see the scene as a series of shapes rather than as recognizable features. Identify the darkest areas and block them in making them as dark as possible with a soft pencil (6B would be a good choice). This will give you more scope for a wide range of grays in your mid tones.

Don't be afraid to change the way you hold the pencil. When you use the side of the pencil, it feels like there is more of a connection between your body and the pencil. You can push more into the paper, and the movements and the weight of your arm are directly translated into the drawing.

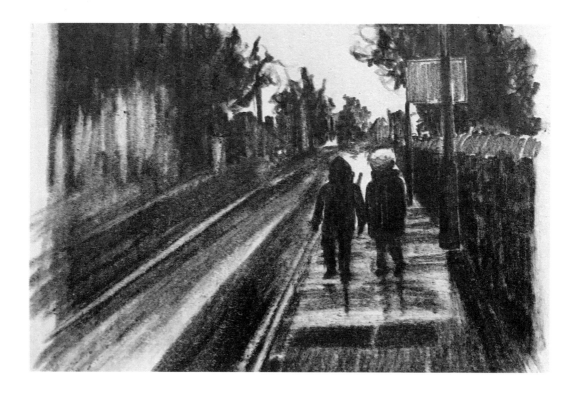

1. Start by blocking out the darkest shapes with a soft pencil. All of this drawing was done using a 10B graphite pencil.

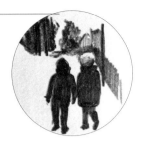

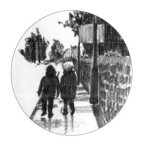

2. Then add detail, using your pencil in a creative way to introduce pattern and rhythm. The surface of the wall is built up in a series of regular, short marks, whereas the tree is a mass of wiggles, suggesting foliage.

3. Keep thinking about what the right mark is for the surface you are drawing. The shine on the wet road here has been drawn with longer strokes which suggest a glossy surface.

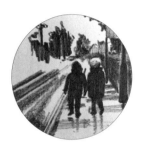

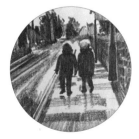

4. Finally, the graphite drawing has been blended using an eraser and a blending pencil to add to the rainy atmosphere.

SMUDGING

Smudging is a technique in which you work graphite into the surface of your paper, using your finger or a blending stump (tortillon). This can help you to create a smooth transition between the light and shadow in your drawing.

In this drawing, the tone was laid down with hatching and cross-hatching, and then smudged to smooth out the marks and give a smooth transition. The clouds in the sky were created by smudging the graphite from the heavy shading at the top of the tree across the paper, and the lighter tops of the clouds were picked out with the edge of an eraser.

TRY IT YOURSELF

1. As in the stippling effect (see page 30), think about the texture of the surface you are drawing and build up the graphite using appropriate marks before you smudge them. To get down large areas of even tone, hatching and cross-hatching are the easiest to use.

2. Using the blending stump to pick up the available graphite will allow you to take it further, and you can use the tip of the dirty blending stump to alter the smudging marks.

3. Using your finger to smudge will give a smoother, larger area of smudgy tone.

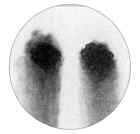

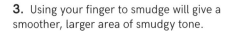

Selwyn Leamy, *The House Across the Street*, pencil on paper, 2020

CREATE DEPTH WITH LINE

Opposite:
Selwyn Leamy,
Studio Window,
graphite pencil
on paper, 2021

Varying your tonal range can give your drawings depth. Lighter tones generally appear further away, while darker tones appear closer. This is a natural phenomenon called atmospheric perspective. You can use this effect to accentuate the sense of depth in your drawing, even if it's not a landscape.

In this still life the objects at the back of the table and the scene through the window are drawn with a much lighter line, which accentuates the feeling of distance. Even in a line drawing you can create an illusion of depth by varying the weight and intensity of the line. Tonal drawings (see pages 20 and 36) are another way to explore the effects of atmospheric perspective.

TRY IT YOURSELF

1. Starting at the top of your sheet of paper, use the side of your pencil to create an area of light tone.

2. Moving down the page, create mid tones by pressing a little harder on your pencil.

3. Finally, press even harder to add dark tones in the foreground. Go back over the area to make it distinctly darker.

4. If you want, use a little smudging to give your shading a smoother, foggier look.

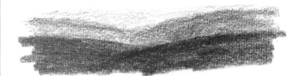

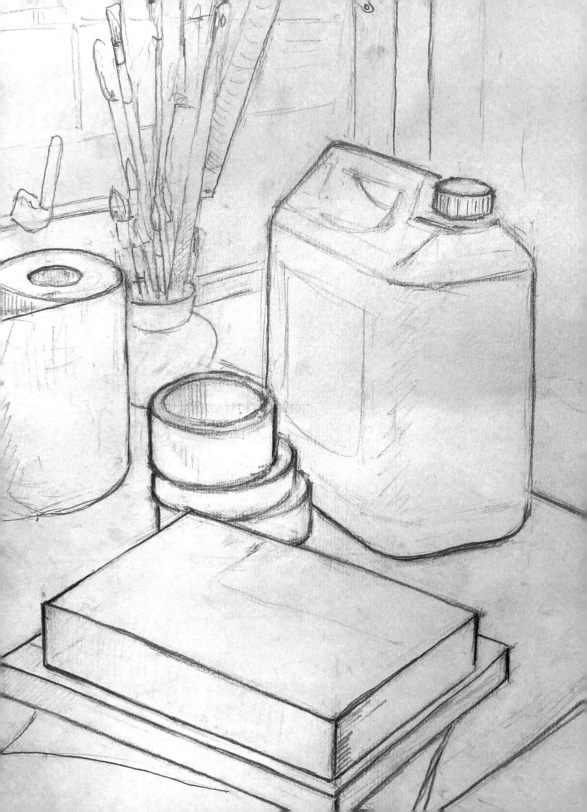

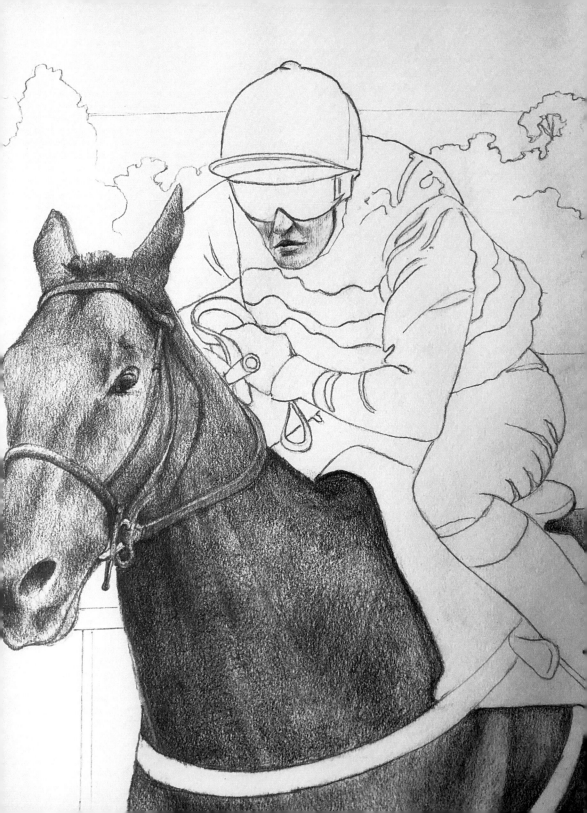

COMBINE LINE AND TONE

Opposite:
Selwyn Leamy,
2.10 Chepstow,
graphite on
paper, 2021

It's easy to clutter up a drawing by including everything that is in front of you, but sometimes it's important to edit out the extraneous information so you can be clear what the focus of your drawing is. One way to do this is by combining line drawing with areas of tone.

Here, tonal areas are used to draw attention to the key parts of the drawing. The deep, rich tones of the horse emphasize its strength and musculature, and the more subtle tones of the jockey's face emphasize his deep concentration. The rest of the drawing is rendered with clear, crisp lines that describe the scene without being distracting. To achieve this the composition is sketched out lightly using a hard pencil, then the outlines are drawn in darker. The use of smudging brings out the sheen of the horse's coat. Part of this drawing's power lies in the amount of paper that is left blank.

TRY IT YOURSELF

Avoid unwanted smudging
To keep your paper pristine, put another piece of paper under your hand as you draw.

Create defined borders
Before adding tone, mask the areas that you want to remain white (with low-tack masking tape), then smudge right up to and over those edges to make a crisp border. You can also use the edge of a piece of paper and an eraser to create a clean edge.

CREATE HIGHLIGHTS WITH AN ERASER

The first marks you put down in a drawing don't have to be the ones that stay. You can start with dark tones and then work back into them with your eraser, removing charcoal to reveal the light of the paper again. You can feel your way through a drawing by putting on and taking off until the drawing finally seems finished. This technique of removing tone to reveal the white of the paper is called lifting out.

This landscape drawing made in County Kerry, Ireland, by Jonathan Farr went through many changes. There is strong contrast between light and dark, conveying a dramatic sense of form, atmosphere, distance, and scale.

1. Start by laying down an area of graphite using a very soft pencil, such as a 6B.

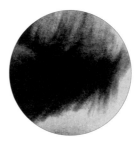

2. Smooth out the dark area by smudging it with a piece of paper, a blending stump (tortillon), or your finger.

3. Use an eraser to create shapes and marks.

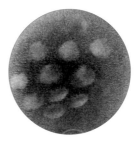

Tip Cut your plastic eraser to create a hard edge, or try a putty eraser, which can be molded into a variety of shapes and points.

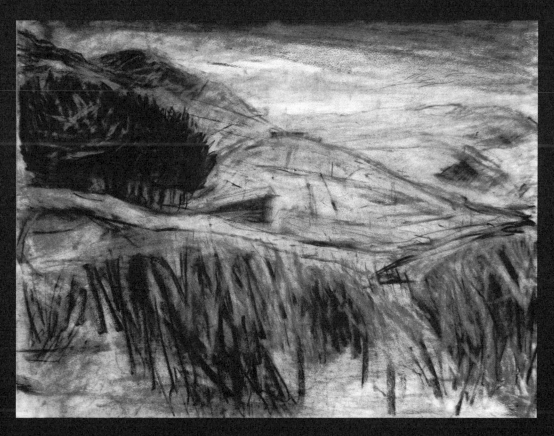

Jonathan Farr, *Cil Rilaig Landscape*, charcoal on paper, 2013

LIFT OUT THEN ADD DETAIL

By adding definition into an image after you have created your tone and lifted out highlights with an eraser, you can build a complex tonal study that also contains detail. This is a great technique for shadowy scenes like this church interior.

1. Use masking tape to define the edges of your drawing. Using the side of a soft pencil, create layers of tone over the whole of the paper. Then smudge the graphite into the surface of the paper as evenly as possible to make an area of mid to dark gray.

2. Lightly map out your composition by gently lifting some of the graphite off the page with your eraser. Now work into the highlights to bring out the white of the paper.

3. Develop depth by darkening the deepest shadows with your soft pencil. Your image will still look quite indistinct and blurry at this stage.

4. Finally, sharpen up your drawing by using the point of your pencil to define the detail.

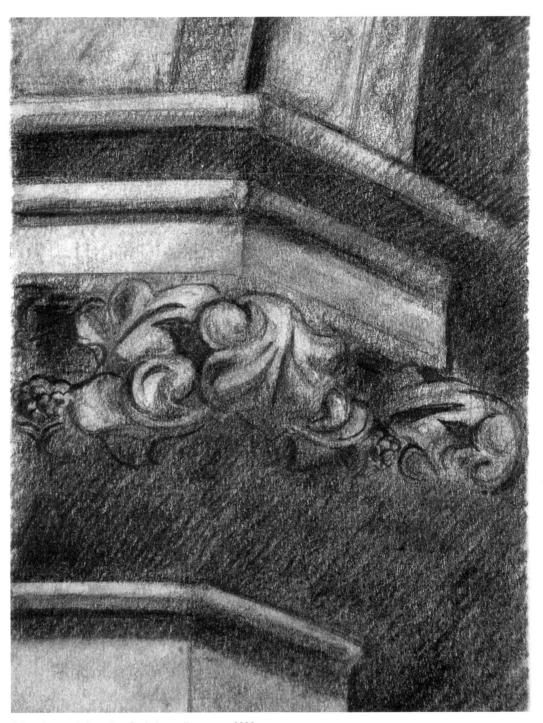

Selwyn Leamy, *St Barnabas Capital*, pencil on paper, 2020

USE HARD PENCILS FOR CRISP DETAILS

Drawing is all about picking the right pencil for the job. The joy of a hard pencil is that it will stay sharper for longer, and give you distinct, fine lines over and over again. If you are interested in details, a pencil with a hard lead will give you the precision to describe that detail. If you want drama and darkness, then a softer, darker pencil is the right tool for the job.

This drawing is not about deep, dark tones; this is about crisp precision and intricacy, exploring the detail and fine patterns of the surface of the leaf. Before putting pencil to paper, spend some time looking really closely at your subject. For a detailed drawing like this it is a good idea to start by lightly mapping out the shape and main features of the subject. Once the structure of your drawing is in place, this gives you the chance to enjoy getting the intricacies and details down onto the paper. Remember to keep looking and constantly check and recheck your subject. Detail can be daunting, but if you give yourself the time, you will achieve amazing results and it can be a fulfilling exercise.

Tip This method of drawing is all about precision and accuracy, so it is important to be looking more at your subject than the paper on which you are drawing.

Opposite:
Jane Fisher,
*Tilia americana
(American
Basswood)*,
graphite and
color pencil on
paper, 2020

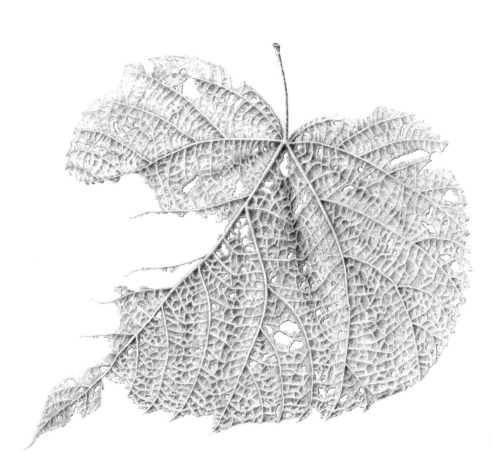

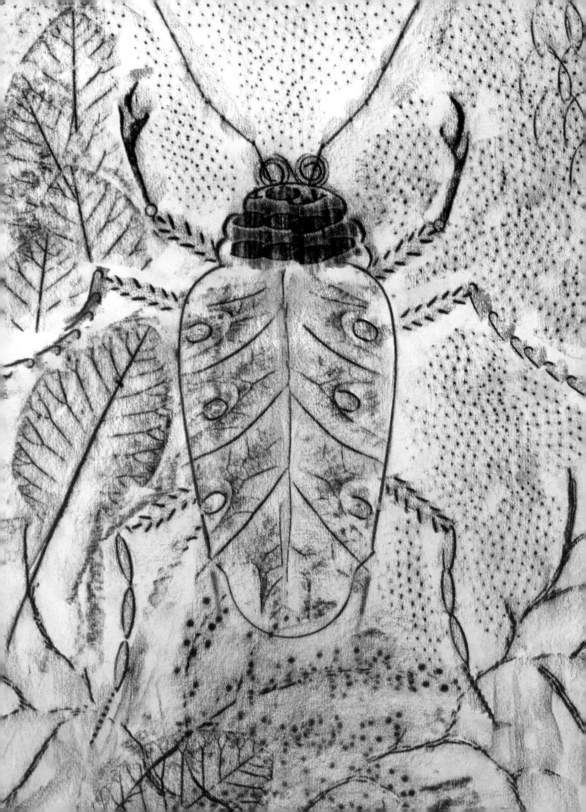

TAKE A RUBBING

Opposite: Claire Drury, *Beetle*, graphite on cartridge paper, 2021

By applying graphite onto a piece of paper that has been placed on top of an object, you can make an impression of it. This is called frottage, and impressions made using this technique are called rubbings. You can take a rubbing from any interesting surface. Use the edge of the pencil rather than the point to bring out raised areas, creating interesting patterns and textures on your paper. Be warned: graphite gets everywhere; you will need to keep washing your hands to avoid unwanted fingerprints.

Artist Claire Drury has used a variety of materials to create this image of a beetle, introducing natural elements to counter the regularity of the patterns on manufactured objects, and layering rubbings of shells and dried leaves to add to the complexity of the image.

1. To make a rubbing of an object, lay it flat on a table and lay a piece of paper over the top. Fold back the corner to check that the object is lined up the way you want it. Experiment with a variety of objects to find the kinds of patterns you want for your final image. Leaves are better when they are pressed and dried out a little, as they are flatter, harder, and easier to handle.

2. Layer your rubbings on top of each other to add to the intricacy of the textures you are creating.

3. Introduce rhythm and pattern to your drawing by using an object repeatedly.

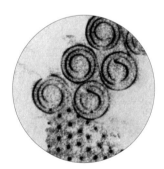

GRAPHITE MONOPRINTING

Opposite:
Rachel Mercer,
*Carbon Copy
Still Life with
Tripod*, graphite
on paper and
biro on paper,
2020

Using carbon paper is a great way to make copies of your drawings. When you have multiple copies, it gives you scope to experiment with your own work. It's magical to see your drawing transposed into a different medium, and it helps you see it with fresh eyes. Carbon copies have a beautiful soft quality to the line, which makes them particularly appealing.

In this example, artist Rachel Mercer started by dividing her composition into quarters and drawing it section by section. This unusual approach can generate some interesting results. Perspective becomes distorted as the drawing grows outwards from the bottom corner. Imagining your drawing as four separate sections before you even begin encourages you to plan your composition.

TRY IT YOURSELF

1. Set up a still-life scene of three or four objects that are personal to you. Try a combination of cylinders and cuboids (books, boxes, bottles, etc.) that have a variety of textures on their surface.

2. Fold a sheet of A4 paper into four quarters, then cut out each quarter.

3. On one quarter, use a pencil to cover one side in graphite.

4. Place the graphite-covered quarter face down over the bottom left-hand corner of another sheet of A4. On top of that, lay another quarter of paper. You will now have three layers: blank A4 sheet (bottom), graphite-covered quarter (middle), and blank quarter (top).

5. Using a biro, start drawing your still life on the blank quarter of paper, starting at the bottom left. You could also use a hard pencil for this stage, but the strong lines of a biro make a good, clear monoprint image. Don't move your paper or the drawing will go awry!

6. You will see your drawing magically transferring onto the bottom sheet of paper.

7. Repeat the process for the other three quarters of your still life.

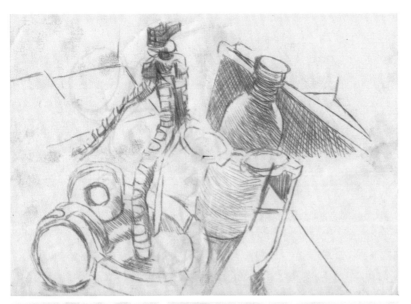

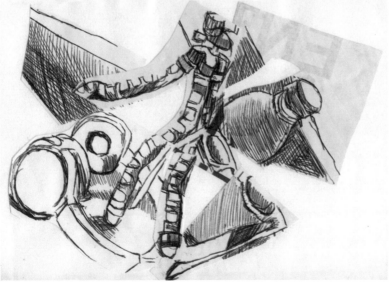

Tip Once you've finished your monoprint image, use your original biro drawings to make a fragmented collage. You will need scissors and a glue stick. Cut around your objects (or through them, if you wish), but don't throw any parts of your drawing away. On another sheet of paper, rearrange your cut pieces—they may overlap or you may choose to leave gaps between them. When you are happy with your arrangement, glue it down.

EXPAND YOUR PENCIL CASE

WHAT ELSE IS OUT THERE?

Now that you've got to grips with graphite pencils, it's time to walk into your local art shop with confidence and ask for something a little more unusual. Here are some different drawing media you might like to try. The best way to find out what they can do is just to have a go and experiment with them. Here are some tips to help you get started.

Color pencils
You can play about with the cheap and cheerful ones you can pick up at any stationery store, but the more money you spend the more pigment you will get, which will give you richer colors.

Watercolor pencils
These pencils lay down pigment that dissolves when you add water to it. Blend your colors then apply water with a brush to create a watercolor-type wash, or work on wet paper to get a more intense color.

Charcoal pencils
Charcoal pencils will give you darker, less shiny blacks than graphite. They come in hard, medium, and soft. They are good for smudging, and cleaner and more precise than a stick of charcoal. They also won't break up in your pocket.

Conté pencils (not sticks)
Conté is made from graphite or charcoal mixed with wax or clay. It is slightly resinous, which allows for the build-up of rich dark blacks. Conté pencils (also called Conté crayons) give a grainy line a bit like charcoal, but sharper.

Chinagraph pencils
These water-resistant, waxy pencils are also called grease pencils, wax pencils, and china markers.

Brush
You'll want a brush on hand if you're going to be working with watercolor pencils. A medium-sized round brush with a decent point is a good choice.

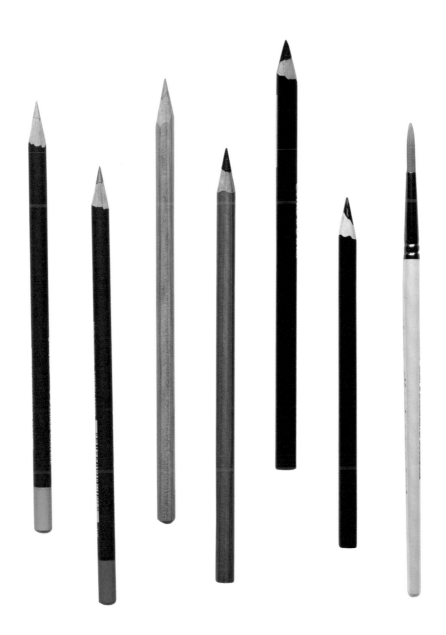

Tip When you're experimenting with a new kind of pencil, buy individual pencils to begin with, as sets are expensive and you may end up with a variety of pencils you will never use.

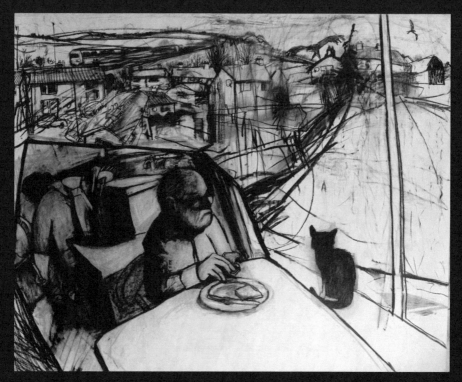

Jonathan Farr, *Breakfast*, charcoal on paper, 2014

CHARCOAL PENCILS

Charcoal pencil is a great medium for dynamic drawings. It can create a range of tones like graphite, but it smudges much more readily and gives a significantly darker tone. If you are going to do a lot of smudging and scrubbing with charcoal, make sure to use a heavyweight paper that can cope with these physical processes, the sturdier the better.

Here, artist Jonathan Farr has used thick charcoal to make dark outlines and dense shadows; he scrubs and smudges the charcoal, then lifts it off the paper with a plastic eraser. Ghost marks of earlier lines are left visible. Movement and stillness are conveyed by varying speed and pressure in applying lines, smudging, and erasing. Some areas are very defined and other parts left more open, allowing them to be unfinished. This large-scale drawing was made using smaller observational drawings as reference. The artist spent days drawing his father and stepmother in their home. There is a stillness and pause in the home interior and the couple, while outside the village, trains, kites, and weather swirl in movement.

Tip Charcoal blunts really quickly, which can give you lovely broad lines, but you can use a blade to shape the end of your charcoal pencil into a point if you want fine lines. Invest in a putty eraser for erasing charcoal or use a plastic eraser to move the charcoal around the surface of the paper.

SCRATCHING FOR TEXTURE

Opposite:
Endre Penovác,
Little Puli, pencil
on paper, 2012

Another feature of charcoal is that it will lift off the paper without using an eraser. Charcoal is a looser medium than graphite, so you can use your finger to dab off areas of tone (this is great if you want a smudgy look—but if not, be careful where you lean on the paper!). You can also use a sharper point to scratch into an area of charcoal, or to add texture to the paper before adding charcoal over it.

In this drawing, artist Endre Penovác started by using the edge of a charcoal pencil to block in the dark mass of the dog. Then he worked on top of the charcoal with a variety of marks, scribbling and smudging to create the detail in the dog's coat. Finally, he used a sharp point to scratch some of the charcoal off the surface and create faint scrawls of highlights in the mass of tone.

TRY IT YOURSELF

Use a tool to scratch into an area of charcoal
Apply some charcoal to your paper, then use a cocktail stick or other implement to scratch into it to create a rough edge.

Use an eraser to move the charcoal on the paper
Try using a plastic eraser to pull lines and marks from the main area of tone.

Scratch the paper before adding charcoal
Scratch into the surface of your paper, then smudge charcoal over the scratched area to bring out the texture.

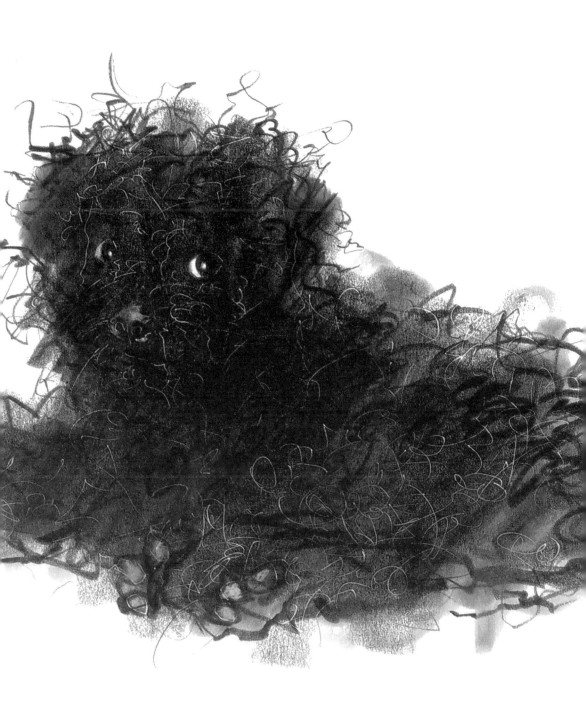

CONTÉ PENCILS

Black Conté pencils will give you fantastic rich, dark blacks that you could never achieve with a graphite pencil. Conté also gives a matte finish, as opposed to the shiny surface of a block of graphite tone. This increases the feeling of density and depth in shadows. Conté pencils do smudge, but they don't lift off as effectively as graphite or charcoal.

Here the Conté has been put down in a frenetic scribble that builds up deep, dark shadows, which have been worked into with an eraser to create areas of light. This energetic mark making contrasts with the more refined edges of the crane, which have been defined using ruler-straight lines. The effect is to create a monolithic, impersonal man-made structure, which thrusts out of the gloom of the dockside murk.

TRY IT YOURSELF

Use fine lines to create patterns
Using a light touch and a sharp pencil, the hatching lines were built up—these are good for creating an area of texture. The dark area of tone was created using the edge of the Conté pencil to create a thicker, grainier line which shows the texture of the paper.

Build up tone with mark making
This block of tone was built up using a series of short, scribbly marks, which were laid on top of each other to create the denser areas of tone. This is a dynamic, expressive mark like we looked at on page 34.

Smudge an area of dense tone
Use your finger, a blending stump (tortillon), or a plastic eraser to pull lighter tones from deep black in a smooth transition.

Tip Try using Conté pencils on tinted paper for a different look.

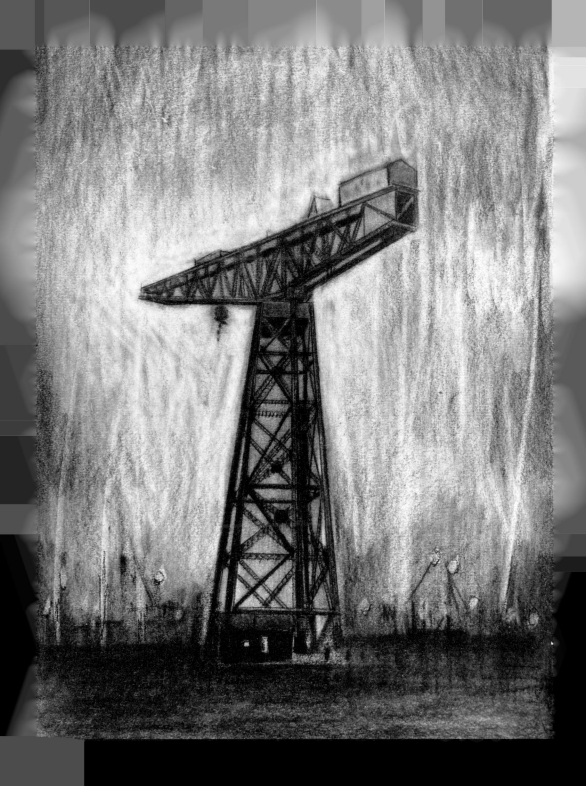

USE COLOR TO CREATE IMPACT

By carefully selecting which colors you include in your drawing, and how much of each color you use, you can create quite a statement. In this sketch, artist Alex Nicholson has limited his palette to three strong colors: black, red, and yellow. He has stripped out a lot of detail from the scene and only drawn part of the reclining figure. Although he has added a suggestion of shadow with the black line, when it comes to the other colors, they are solid blocks of red and yellow with no idea of form or depth. This simplifies the image and gives it real impact.

Primary colors The primary colors are red, yellow, and blue. They are the building blocks of color and cannot be made by mixing other colors. However, you can create other colors by combining them.

Tip Identify the focal point in the scene you are drawing and make that the heart of your composition. Leaving space around it will let your drawing breathe.

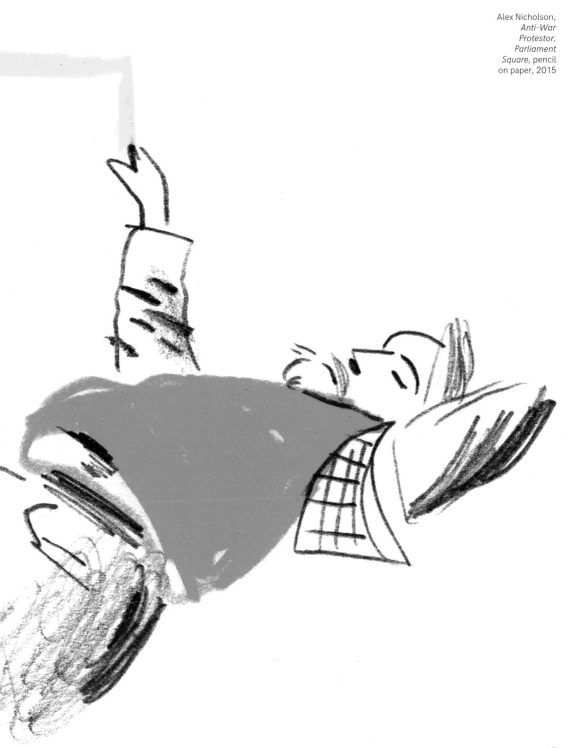

Alex Nicholson,
*Anti-War
Protestor,
Parliament
Square*, pencil
on paper, 2015

COLOR AND LINE

When drawing in color, you don't have to color in everything—just select the areas that interest you and draw them. Look at your subject and lightly sketch out the composition. Then pick a small number of color pencils. Be brave and choose a bold color to draw the outlines. You can make the colors brighter in your drawing than they are in real life, they don't have to be totally naturalistic. Just give a suggestion of the color without blocking the whole area in.

In this intimate portrait of his sleeping boyfriend, artist Wilfrid Wood has allocated a different color to each element of the composition: clothing, face, hair, and pillows. This lends a childlike naivety to the portrait and adds to its charm.

Secondary colors Secondary colors—orange, green, and purple—are made by mixing two primary colors together. Any set of color pencils will have some secondary colors included, but you can also mix your own.

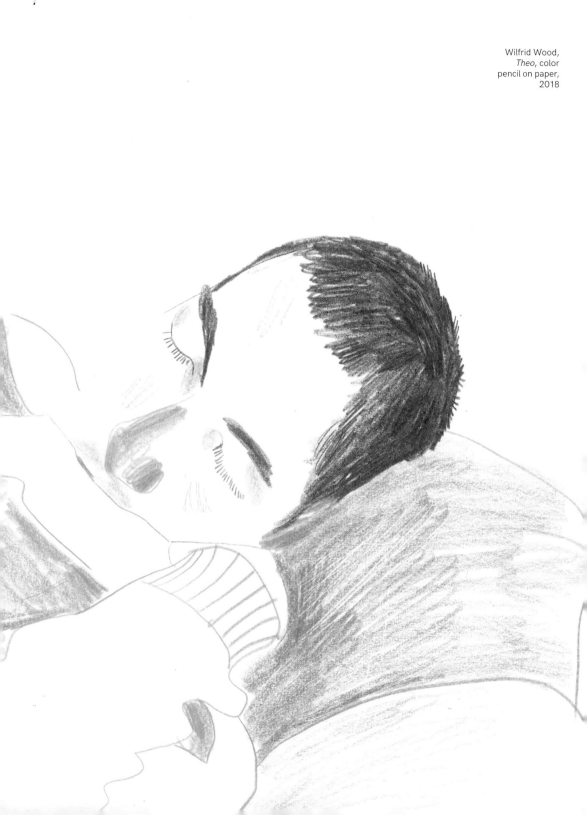

Wilfrid Wood,
Theo, color
pencil on paper,
2018

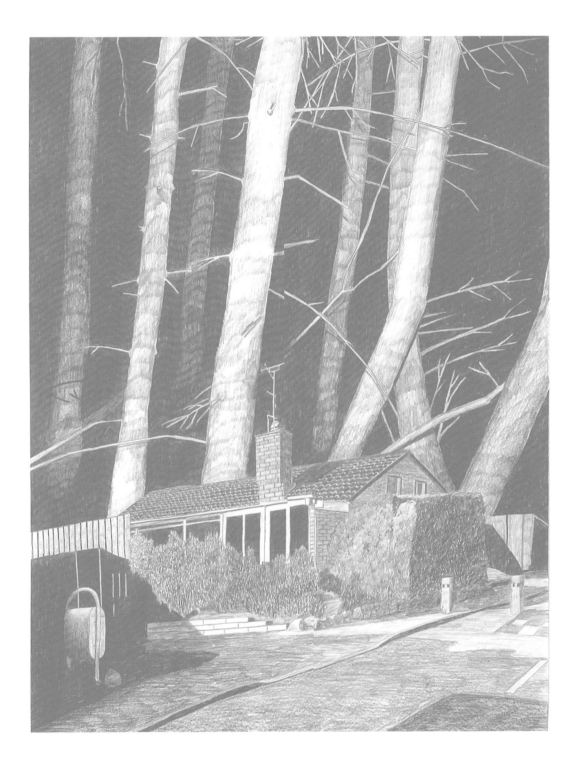

USE COLOR TO CREATE A MOOD

Opposite:
Morten Schelde,
*Children of
Suburbia #34*,
pencil on paper,
2001

When introducing color to your drawings, you don't need to use a variety, you could choose just one. A drawing made with a single color is called a monochromatic drawing. In this example, artist Morten Schelde has created a monochromatic drawing in red. Using a color pencil to make a tonal drawing is just the same as using a graphite pencil, but rather than creating grays and blacks you build up a more intense color.

Using color in your drawings can help you create a mood. The red in this drawing feels cinematic, reminiscent of a blood-soaked horror film, or you might make another association. Our reaction to colors can be deeply personal. Traditionally, distinct characteristics are attributed to different colors: for example, yellow feels sunny, bright, and hopeful; blue feels cold, wintry, and melancholy; and black feels dark, dramatic, and gloomy.

Warm color palette (reds, oranges, yellows).
These colors are often associated with feelings of
happiness, passion, anger, love, energy.

Cool color palette (blues, purples, greens).
These colors are often associated with feelings of
sorrow, melancholy, peace, tranquillity.

SUGGEST FORM WITH COLOR BLENDING

As well as adding bold blocks of glorious color to your drawings, color pencils can be used to build up tonal value in your drawings. Layer different colors, blending as you go, and you can transform a two-dimensional circle into a three-dimensional sphere.

For example, in this study of a bowl of pears, the shadows are built up gradually with delicate hatching and cross-hatching to create a smooth blend of colors. A darker brown is layered on top of the blues and purples of the bowl until the shadows have the necessary depth and density. The different tones that give the pears form are made from a blend of greens and browns, the colors you find on them in nature. Blues are introduced to create shading on the fruit.

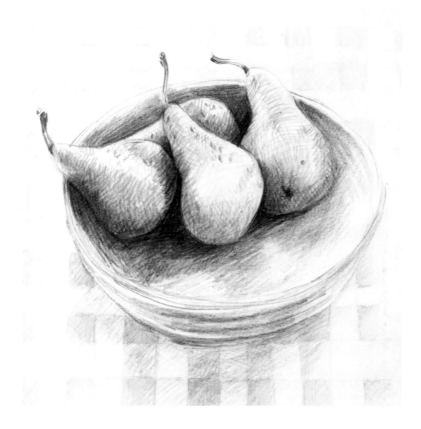

Eve Blackwood,
Pears, color
pencil on paper,
2020

1. Choose a spherical object to draw, and select three colors that are next to each other on the color wheel: one light, one mid tone, and one darker tone. In this example, the colors are yellow, orange, and a reddish brown.

2. Start by looking carefully at the way the light is hitting the sphere. Then lay down the light color, leaving an area uncolored that will form the highlight.

3. Take your time to carefully build the tonal value on the opposite side of the sphere from the highlight. It's important to have a clear idea of the direction the light is coming from when you are shading a sphere. Knowing where the light is coming from will also tell you where to put the shadow.

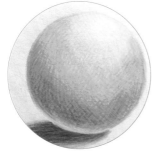

4. Once you are happy with your mid tone, fill in the darker tones and shadows with your darkest pencil.

Analogous colors Analogous colors sit next to each other on the color wheel. These colors work well when you put them together in a drawing. For example, green and yellow are neighbors on the color wheel. If you mix these two colors, you create a new color, yellow-green, that has attributes of both. Thus, the three colors are analogous because of their close relationship to one another. Analogous colors will give your drawing a sense of harmony.

LET YOUR EYE DO THE MIXING

We've looked at stippling as a technique for creating tone (see page 30), but you can also use it to mix colors. Distinct marks of one color next to marks in another color will appear to blend together when you look at them from a distance: for example, an area composed of yellow and blue dots will appear green when you step back. This is called optical mixing.

When you look at this drawing by artist Marcus James up close, you will see a huge variety of individual marks and textures. But as you stand back they transform into a misty, atmospheric landscape. The time-consuming and painstaking process of creating the many tiny marks makes the surface of his drawing as fascinating as the optical mixing effect.

1. Choose pencils in two primary colors. Starting with one color, build up an area of tone using dots. Create darker areas by grouping your dots more closely.

2. Now introduce your second pencil, adding new dots among those made in the first color.

3. Every so often, move away from your drawing to check how the new secondary color created by the different colored dots works from a distance.

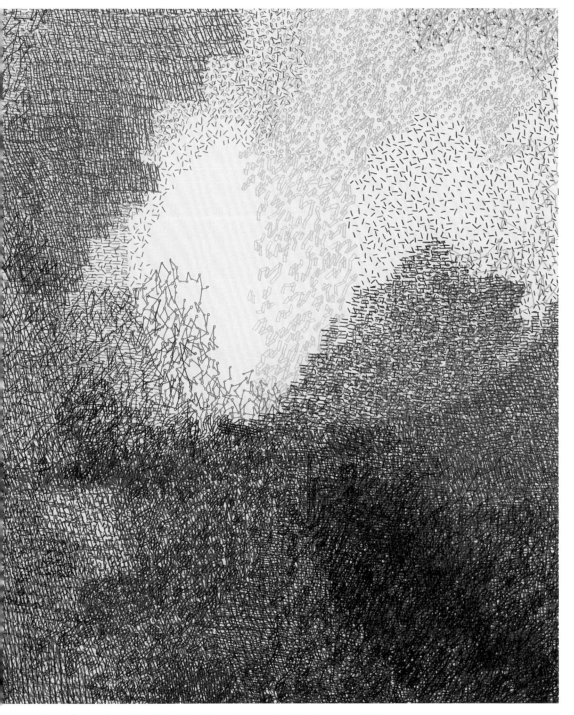

Marcus James, *Ascending Bidean Nam Bian*, color pencil on Fabriano paper, 2015

COLOR CROSS-HATCHING

We have looked at using hatching and cross-hatching with color pencils to create smoothly blended transitions between colours (see page 72), but sometimes you may want to keep your hatching lines visible to create texture, movement, and rhythm in your drawing. In this technique, you build up different colors by hatching and cross-hatching over one color in another color or colors.

 This drawing by artist Andrea Serio is all about letting the individual colors in a landscape combine to make more complex colors. Look closely and you will see that the greens that he has used to create the foliage have been modified by adding yellows and blues in order to make more subtle shades. That allows him to capture the hazy blues in the shadows.

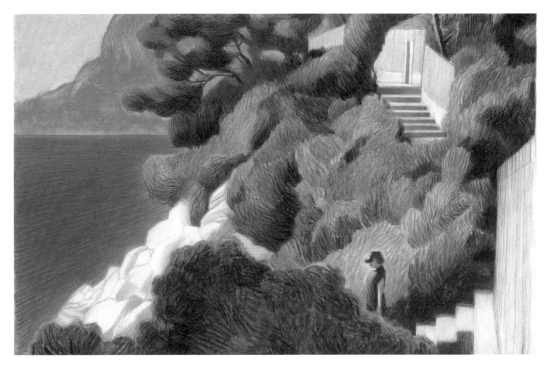

Andrea Serio, *Promenade Le Corbusier*, wax pastels and color pencils on paper, 2017

1. In nature you don't normally have uniform blocks of a single color, so start by looking carefully at a landscape to identify the different colors within it. Using the most dominant color, build up an area with hatching. Make your hatching more dense to create darker areas.

2. Now introduce a second color, and mix it by hatching over the top of the first color. Cross-hatch in the denser, darker areas to create more complex shades.

3. Experiment to create a range of colors beyond the basic colors of your pencil set.

Lily Vie, *Flowers*, color pencil on paper, 2020

ADD OUTLINES FOR CONTRAST

Outlines can give a punchy, graphic quality to your drawing. By outlining in a complementary color, you can add even more impact. Complementary colors are opposites on the color wheel and contrast strongly with each other, generating visually arresting color combinations. When used together, each will appear brighter and more prominent. Artist Lily Vie makes use of the complementary colors orange and blue in her drawing. Outlining in bright orange adds a real vibrancy to her limited palette of blues.

TRY IT YOURSELF

1. Pick color pencils in two complementary colors.

2. Use one of the colors to draw an outline.

3. Fill in the outline with the contrasting complementary color. Use a few different tones of this second color to create depth (e.g. dark and light blue).

4. If you want to use very dark outlines (like the dark blue in Lily's drawing) add these last.

Complementary colors Complementary colors sit opposite each other on the color wheel. Every primary color's complementary color is a secondary color that is a mix of the other two primaries on the color wheel. For example, blue's complementary color is orange, which is a blend of yellow and red. The other complementary pairs are red and green, and yellow and purple.

CREATE A LANDSCAPE WITH PATTERN

Below:
Lui Ferreyra,
Adumbration 2,
color pencil on
paper, 2019

Simplifying reality into pattern and shapes is all about seeing the world in a different way. Try breaking your subject down into segments of color. Make pattern and color the main stars of your drawing.

In this landscape drawing, artist Lui Ferreyra fragments his scene into a series of geometric shapes, which he outlines first. The hatching lines that he fills these shapes with suggest the angles of the slopes of the mountains and the textures of the trees. The tonal paper adds a warm brown mid tone, which makes the white clouds stand out. This is still a recognizable landscape but you could take it a step further and just make it about pattern if you wanted.

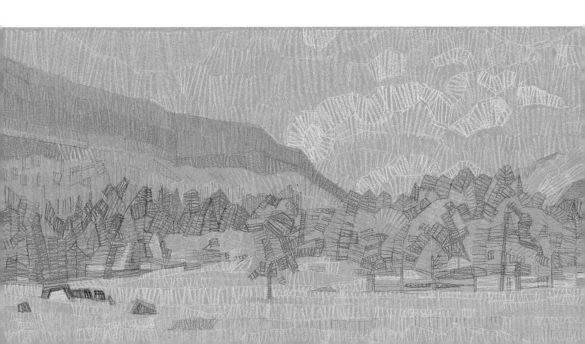

Explore the effects of different colors on toned papers
Against a mid brown paper, warmer, brighter colors like yellows, reds, and oranges will look like they are closer, while the cooler, paler colors like white, grays, and blues will look like they are more distant. Try the same colors on white paper and note the different effect.

Use different strengths of marks
The strength of the marks that you make will add to a feeling of depth. Experiment with using stronger, darker marks to make objects appear closer.

Color combinations
Play with complementary colors to create lively color combinations that will further abstract your drawing.

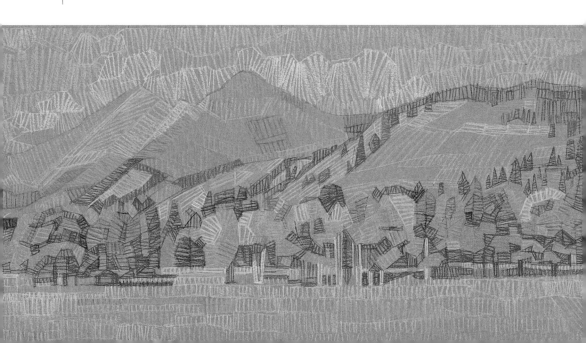

WATERCOLOR PENCIL

Below:
Eve Blackwood,
Octopus, water-
color pencil on
paper, 2020

Watercolor pencils give you the control of a pencil but with the ability to convert all, or part, of your drawing into a wash by adding water to the paper. Water activates the pigment contained in the pencil marks, allowing you to spread it with a brush. The heavier your line, the more pigment there will be on the page. The amount of water you add affects the color: the more water you add, the more diluted the pigment will be and the lighter the color, while less water will maintain the intensity of the color.

Once you have created the wash, you can go back in with your watercolor or other pencils to add detail; add more pigment to make an area darker or alter the color. Because you will be adding water to your drawing, it is important that you use a heavier-weight paper that will not buckle.

When using watercolor pencils you will also need a brush. A good choice would be a round brush with a good point. Like a pencil, a brush has a tip and a side (belly) that will give you different marks depending on the way you hold it and the amount of pressure you apply.

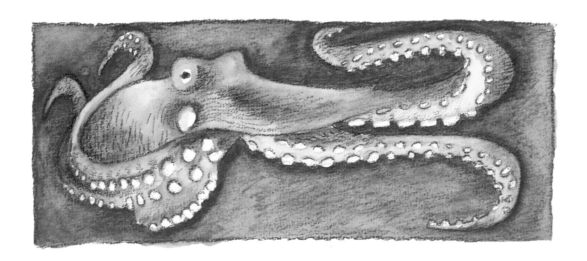

Lay down the pencil
Put down some pencil on your paper, building up darker areas where you want a stronger color.

Make a wash
Add a small amount of water to your brush and apply it to the pencil to activate the pigment. Try adding more water to dilute the pigment further and make a lighter wash.

Blend your colors
Try blending two colors together as you pull the pigment along with the brush. You can add lots of water and allow different colored pigments to bleed together. Experiment with how you use the brush. The edge will give a broad wash of color; the tip allows you to make a finer, more controlled line. Draw a line of pencil at the top of your page and create a subtle graded wash by pulling the pigment down the page gradually with the edge of the brush.

Add detail
Once your wash is dry, work back into your drawing with your watercolor pencils to add pigment to create darker areas or to add pattern and detail.

USE WASH TO CREATE TONE

As we have seen, tone helps you build up form and create a sense of depth and distance in your drawing. With graphite pencils, you do this with a mixture of light, mid, and dark tones. It's exactly the same with watercolor pencils, except that you can create tone by adding water rather than by adding more pencil. You don't need lots of colors – you can work with just one. Using the variation between darker, less diluted areas and lighter, more watery areas, you can create the shading you need to make a convincing three-dimensional image. In this drawing, the watercolor pencil helps to create a rich variety of grays as well as deep intense darks, which emphasizes the dramatic lighting. This technique is a wonderful hybrid of drawing and painting.

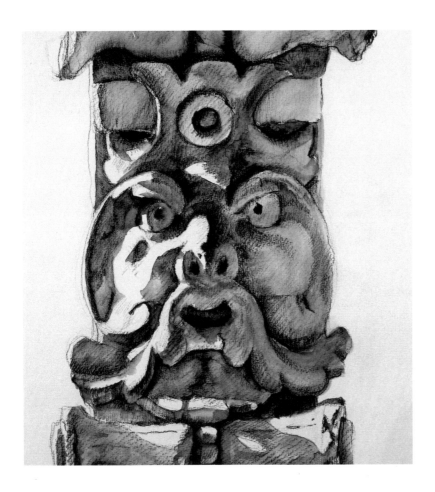

Eve Blackwood,
*Architectural
Study*, watercolor
pencil on paper,
2020

1. Using a watercolor pencil (a dark color is more effective for this) draw the outline of an object, making sure that you use a thicker, heavier line on the areas where you will need more pigment to create the shadows. The whole of the object should have color, apart from the highlights, but there should be a variation in the color depth.

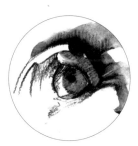

2. Take a brush and add water to dissolve the pencil and move the color around the paper.

3. Dry your brush on a rag, then dip it into the wet pigment to lift out any excess color.

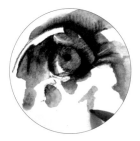

4. Use the pigment on the wet brush to add color elsewhere in the drawing.

5. Work back into the dry drawing with your pencil to add detail and texture.

Tip Prop up your paper at a slight angle, so that the top of the sheet is higher than the bottom. This will encourage the wet paint to move more easily over the paper.

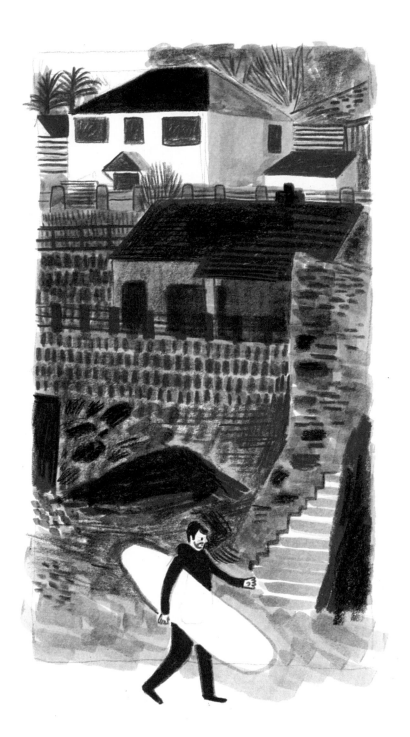

BUILD UP TEXTURE OVER A WASH

Opposite:
Emma Carlisle,
*Surfers at
St Agnes,
Cornwall,* pencil
on paper, 2018

Once you have added water to a watercolor pencil drawing to create a wash, try drawing over the wash while the paper is still wet. This will give you a bold, defined line that you can use to add detail and texture. In this color pencil and wash study, artist Emma Carlisle has used a variety of marks to express surfaces and patterns: short, stubby vertical marks for the stones in the sea wall; differently shaped horizontal marks for the larger, irregular stonework of the stairwell; and longer, radiating lines for the trees in the background. Look for patterns and textures in the scene that you are drawing. If you look closely you will find rhythms of repeating shapes and lines, whether in your garden wall or your dog's coat.

TRY IT YOURSELF

1. Start by creating a block of dry color.

2. Add water to disperse the pigment and create a wash.

3. Then work on top of the damp wash making bold, decisive marks with a darker color pencil.

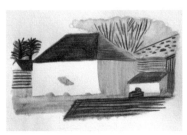
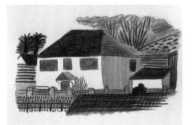

BLENDING WITH WATERCOLOR PENCILS

You don't have to stick to the colors that are provided in your watercolor pencil set. As with normal color pencils, by blending the dry watercolor pencil colors on the page you can create a variety of shades and tones of each color: for example, greens can be yellowish or blueish. Much like color cross-hatching (see page 76), blended colors add complexity to your drawing and can give you scope to create layers of more interesting color varieties.

Once you have blended your colors with your watercolor pencils, use a wet brush to create the complex colored wash. To lighten the blended color dilute the pigment by adding more water and dragging it out along the paper.

TRY IT YOURSELF

1. Set aside a page to experiment with two- and three-color blends to find out what you can achieve.

2. Start by laying down a few lines of yellow. On each line introduce a different color, starting at the other end and working towards a blend in the middle.

3. Use a clean, wet brush to create a colored wash of the blended color.

4. You can blend colors by creating dry patches of intense pigment on your page and then use a wet brush to allow the colors to flow together as the pigment is released into the water.

5. You can make a small amount of pigment go a long way by creating a small patch of intense pencil and then pulling the pigment along the paper using a wet brush.

6. If you sprinkle salt onto the wet wash the pigment will gather around the grains as it is drying and add texture to your drawing.

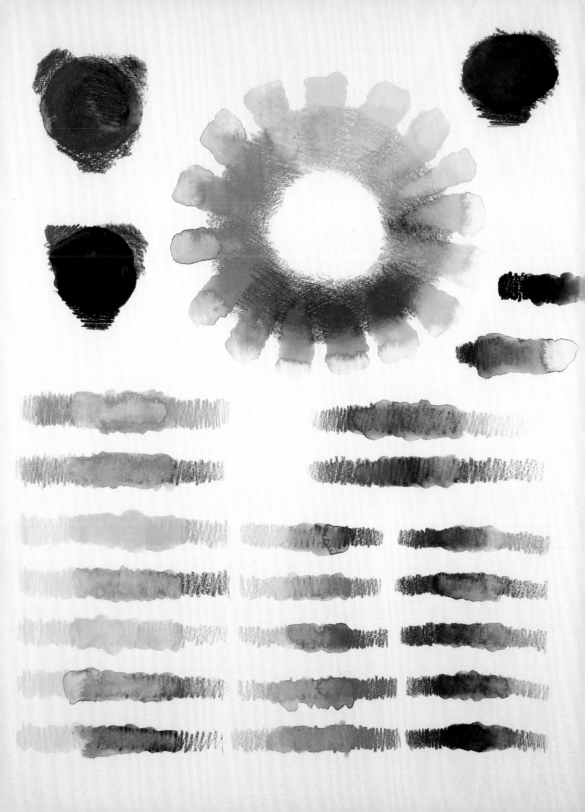

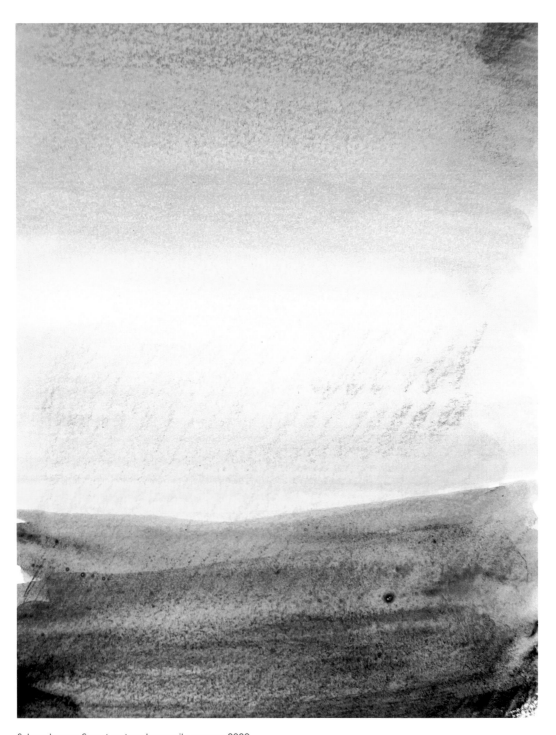

Selwyn Leamy, *Sunset*, watercolor pencil on paper, 2020

THREE-COLOR BLEND AND WASH

Watercolor pencils are great for creating a wash of a single color, which you can then work on top of. But you can also use watercolor pencils to create complex washes with more than one color. This technique can be used to create effective skyscapes. For example, a soft blend of blue, reddish brown, and yellow can be used to convey the colors of a sunset.

1. Create a dry blend of the three colors we are using for our evening sky: blue, reddish brown, and yellow. Use more pressure to apply more pigment in the darker areas—the dark blue at the top of the sky that is fading to night and the yellow at the bottom, where the sun has just dipped below the horizon.

2. Prop your paper up at a shallow angle so the water will run towards the bottom of the page. Then load your round brush with clean water. Using the side of the brush to get a broad stroke, work your way down the paper with smooth horizontal brushstrokes. Be careful not to go back up towards the top as you will muddy the blend.

3. Once you have completed the wash, even if it is not perfect, don't be tempted to go back over it. Add some areas of darker brown and blue at the bottom of the wash to create the landscape.

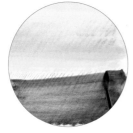

4. In this example, Selwyn added the landscape once the wash was complete, but while the paper was still damp. You could also do it after the sky wash has dried. Apply another wash of water to blend the landscape colors.

MIX YOUR MEDIA

When you want to use a number of different media in a drawing, it is really important to have a think about what each element is bringing to the table. If you just pile in there with lots of different things, your drawing can quickly become a muddy mess.

In this 15-minute sketch, Sophie Peanut has used watercolor pencils as a starting point to sketch in the hills and reservoir, adding lots of texture and movement. Then she has added watercolor paints to create a wash, which has dissolved and mixed with the pencils. Some splattered color makes the scene feel a bit rainy. Finally, she has defined the main elements of the scene with a waterproof fine black pen, which helps to bring a sense of order and definition to the scene.

Opposite:
Sophie Peanut,
*Withens Cloth
Reservoir*, Inktense
water-soluble pencils,
pen, water brush, and
watercolors on paper,
2020

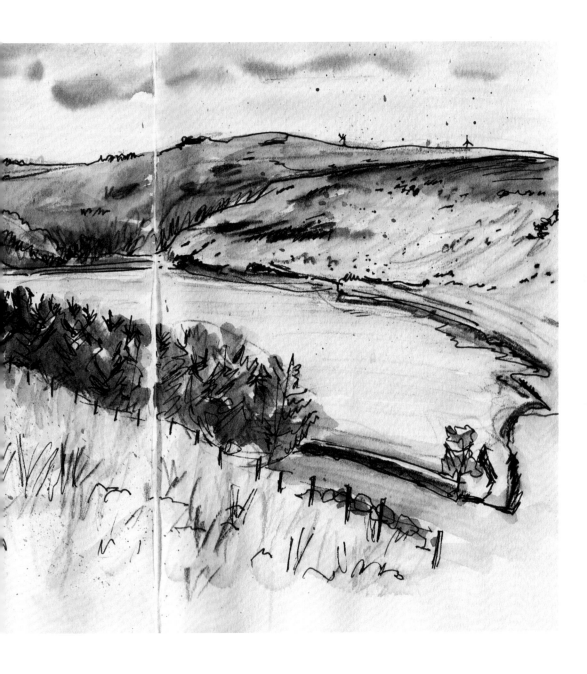

BLOCK WITH WAX RESIST

Wax resist is a useful technique to use in conjunction with watercolor pencils. By applying oil pastels, wax crayons, or even a candle sharpened to a point, you can protect areas of your drawing from a color wash.

Here water-resistant white oil pastel has been used to create areas of wax resist that form the trunks of silver birch trees. These stand out in contrast to a wash of vibrant autumnal colors, full of rich oranges and pinks. Over the wash, pencil details have been added to create the texture of the bark and outline the spindly branches. This technique is great for making powerful, high-contrast drawings.

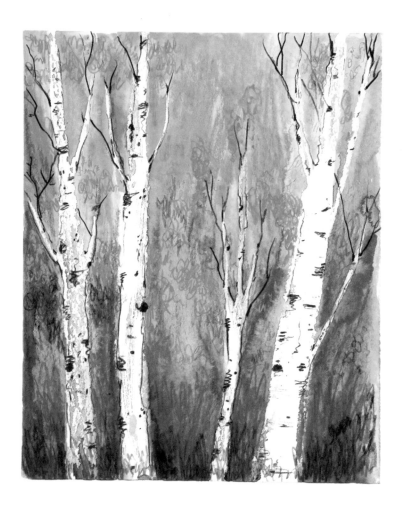

Eve Blackwood, *Silver Birches in Autumn*, water-color pencil and oil pastel on paper, 2020

1. Begin by drawing your areas of wax resist, using oil pastel or another waxy, water-resistant medium. Then add dry color around the wax resist using watercolor pencils.

2. Apply water to the watercolor pencil to create a wash for the background. The pigment will spread to the edge of the wax resist but no further. This creates a crisp edge, which means that you can be really loose and free with your brushstrokes.

3. Once the wash has dried, you can work on top of it with a dry blend of watercolor pencils to deepen a color or to make a more complex color. You could also add water to the new color to make another wash.

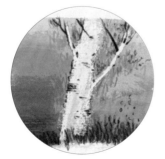

4. Finally, use dry watercolor pencils on top of the wax resist and the color wash to add detail with a variety of color and texture.

SURFACES AND SKETCH-BOOKS

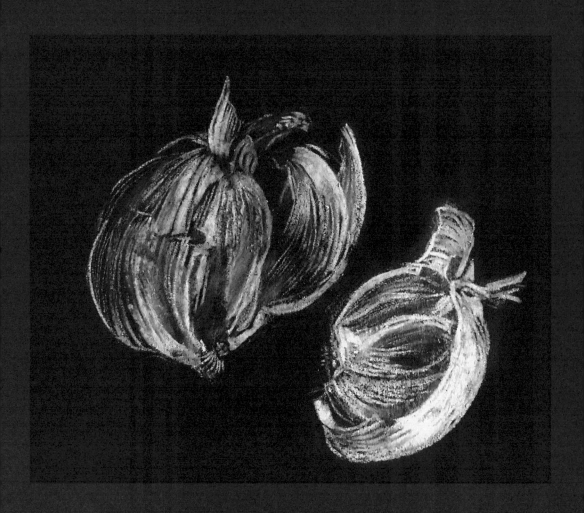

WHITE ON BLACK

Opposite:
Rachel Mercer,
Garlic, white
pencil on paper,
2021

A great way to create impact in your drawings is to use contrast. White watercolor pencils or waxy chinagraph pencils give a striking effect when used on black paper. The white watercolor pencil will give a fainter line but will allow you to create a wash, while the sticky, water-resistant chinagraph will give you a strong, punchy, if slightly grainy, line.

In this drawing, Rachel Mercer chooses to use a white pencil on black paper to draw the papery skin of the garlic bulb, creating a clean, bright image full of contrast. By varying the pressure she is able to produce a bolder line to describe the edge of the bulb, while in other areas she builds up layers of white to create a subtle glow that makes the garlic stand out against the black paper.

TRY IT YOURSELF

Experiment with a variety of pencils on black paper and explore the different effects they generate:

Chinagraph pencils are sticky and bright.

Watercolor pencils have color that is not as strong as a chinagraph's, but they can be diluted to create a wash.

White pencils are essential when working on dark surfaces, as you will need to create the highlights that would normally be provided by the white paper.

Color pencils will also work on black paper, and a black pencil can be very effective when used over the top of other colors.

Metallic pencils can also be very effective.

 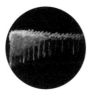 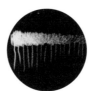 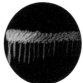

| Chinagraph pencil | Watercolor pencil | White pencil | Color pencil | Metallic pencil |

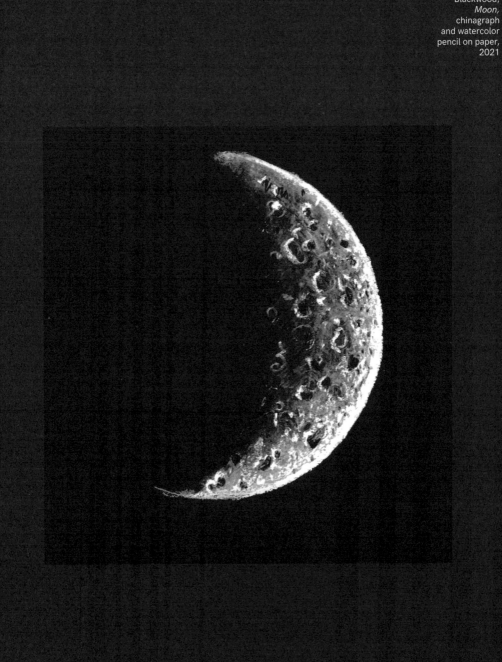

Below: Eve
Blackwood,
Moon,
chinagraph
and watercolor
pencil on paper,
2021

FOCUS ON HIGHLIGHTS

Working in white pencil on a dark surface can allow you to create a drawing entirely of highlights, as in this drawing of the moon. In this example you will see the difference between the effect of a white watercolor pencil and wash, and the bolder, brighter whites of a chinagraph pencil.

1. First sketch out the light side of the moon with a white watercolor pencil.

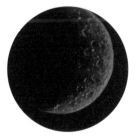

2. Then use a clean, wet brush to add water, creating a wash to make a smooth gradation from white to black.

3. Work on top of the wet paper with the watercolor pencil to bring out the details.

4. Once the watercolor is dry, add highlights with a chinagraph pencil, which gives a stronger, brighter mark.

5. Finally, use a black pencil for the details in the shadows.

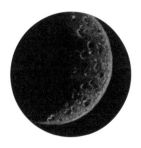

COLLAGE

Opposite:
Asimina
Hollingworth,
A Family, pencil
and collage,
2020

A collage is a picture that is made up from pieces of paper, photographs, fabric and other printed things stuck down onto a surface. Incorporating this technique can add interest and personality to your drawings. You might also find some inspiration in what is printed on the materials you find.

The vintage envelopes and papers in the background of this collage by illustrator Asimina Hollingworth set the scene for this family group that harks back to stilted Victorian studio portraits. She has worked on top of the collage with graphite pencil to build up the detail in the faces and to create the thick, dense blacks of the matriarch's dress. The red dots on the cheeks are another layer of added collage.

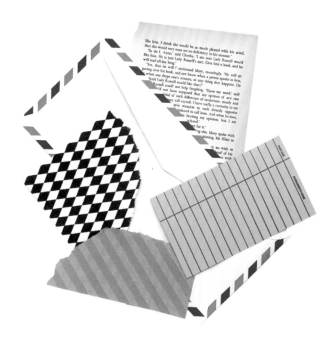

Tip When making collages, you will most likely be using a variety of different papers. Pencils will work differently on different surfaces: for example, waxy surfaces like train tickets will be harder to cover. Try to incorporate the patterns and designs of the papers into your drawing.

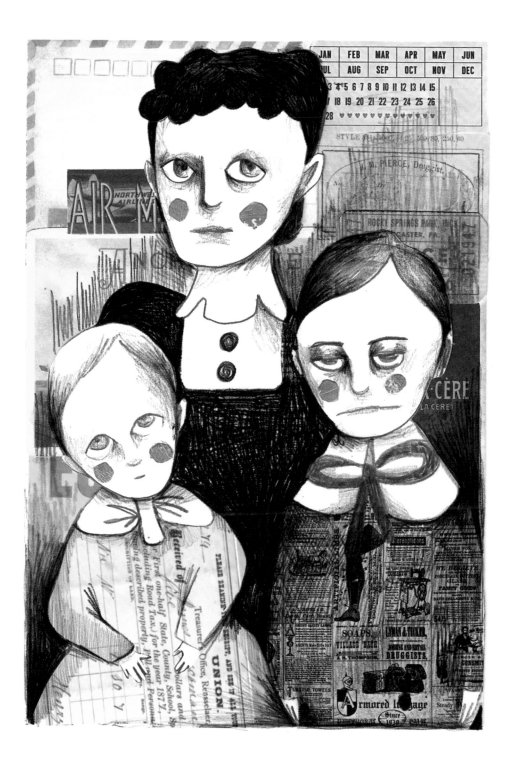

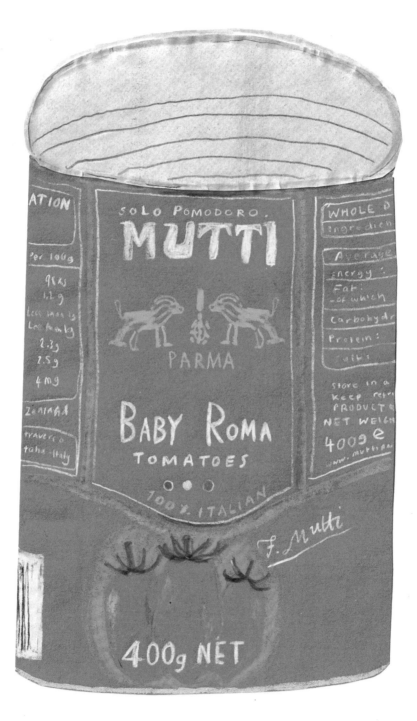

MAKE A STATEMENT WITH COLORED PAPER

Opposite:
Lucia Vinti,
Mutti Tomatoes,
collage and
drawing (digital),
2021

Unlike the collage in the previous chapter, this technique is not about cutting out different papers to make a composition, but isolating one bold color to create the shape of the object in front of you. Try defining the outline of the object by cutting out a piece of colored paper to create an area of strong contrast to your background.

Artist Lucia Vinti uses this technique to excellent effect. She chooses an intense red paper and cuts out the simplified shape of her tomato tin. She then works on top with color pencils to bring out the character of the object and recreate the details of the package design. This approach is all about the impact of the color. Vinti is not interested in shading or three-dimensional effects here, this is a flat, graphic drawing.

Tip Remember that the color of the paper will affect the color of the pencil. You will need a variety of color pencils that range in tone from lighter to darker than the paper. Good quality pencils that have lots of pigment and are slightly softer will work really well.

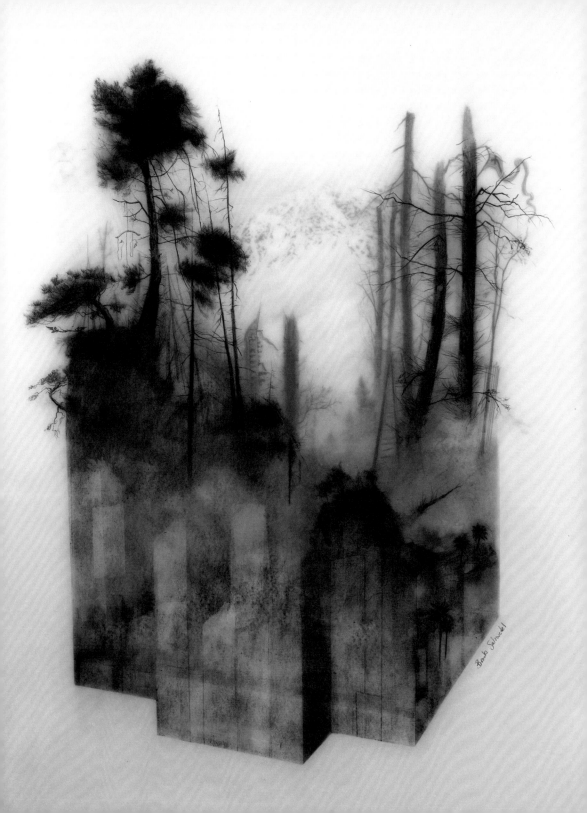

TRACING PAPER

Opposite:
Brooks Shane
Salzwedel, *Seven
Sails,* graphite,
color pencil, tape,
and mixed media
on panel, 2018

Translucent tracing paper is normally used for transferring your drawings from one surface to another. You can, however, also use it as a drawing surface and build up an image over multiple layers to mimic the effects of atmospheric perspective.

Brooks Shane Salzwedel uses a sophisticated self-taught technique with translucent plastic film and resin, as a way to create a murky, mysterious atmosphere in which the forest and mountains appear to fade into the distance. The translucent surface he uses is Mylar, or Dura-Lar, which was originally used for defusing light in film and photography.

You can create this effect by using layers of any semi-transparent paper, such as tracing paper. As you add more layers, the images on the bottom become fainter and the details and color more indistinct. This creates an illusion of depth that is great for landscapes.

TRY IT YOURSELF

1. Cut three pieces of tracing paper of equal size. Then tape them onto a piece of paper or cardboard with a strip of masking tape at the top. This will help you to align the drawings as you go. On the bottom piece of tracing paper, draw a distant scene. You can use graphite or color pencils for this.

2. Then, on the middle piece of tracing paper, draw the mid ground of your scene.

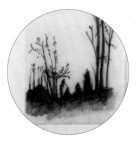

3. Finally, on the top piece of tracing paper, draw the foreground details. To create a misty atmosphere, smudge the graphite.

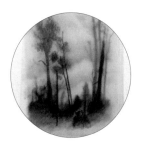

107

TONAL PAPER

Opposite:
Leo Macdonald
Oulds, *Rabat
Medina*, felt-tip
pen and pencil
on paper, 2019

Tonal paper is good for all drawings, landscapes, and portraits. It offers a neutral background onto which you can work in your highlights and shadows. This is great for quick sketches as you don't have to create all the mid tones. Unlike Lucia Vinti, who chooses a dominant color on page 104, tonal paper should be a neutral gray or buff, which will not fight against the other colors in your drawing.

In this lively sketch of a Moroccan souk, Leo Macdonald Oulds sums up the atmosphere and bustle of the market with just a few blocks of color pencil. Some quick strokes that suggest detail and figures are balanced by heavier blocks of shadow. The white pencil used for the highlights and the canopy stands out just enough against the neutral mid-tone paper to give a sense of light. Patterns in the market stalls are picked out using marks and colors that add to the texture and rhythms of the scene.

TRY IT YOURSELF

Choose paper in a color that suits your subject
Yellow or brown colors will bring a warmth to your drawing, which is good for skin tones. Blues and purples will make it feel cooler, which might better suit a landscape or cityscape.

Try cardboard
If you don't have any mid-tone paper such as sugar or pastel paper, try the inside of a cereal packet or smooth packing cardboard. If you use thicker, corrugated cardboard, be aware that the lines of the corrugation will come through into your drawing. Remember that the color of the paper will affect the color of the pencil, as in Lucia Vinti's drawing on page 104.

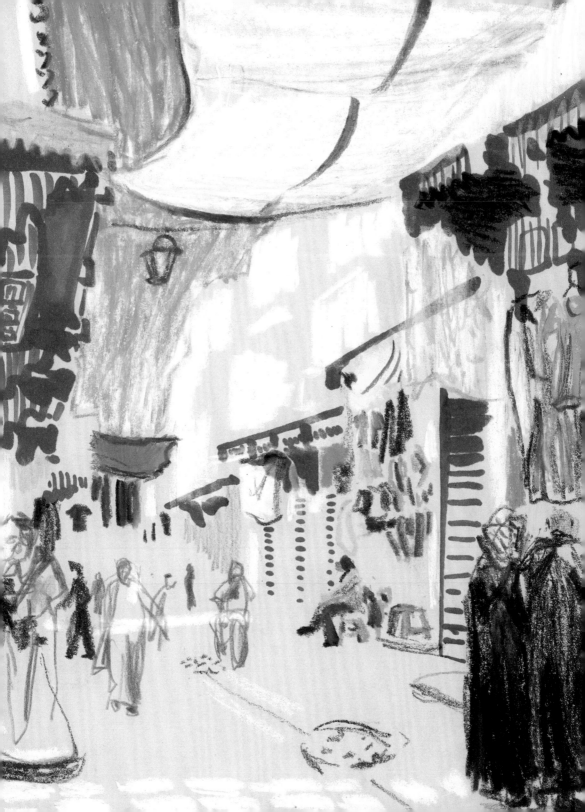

MAKE A TONAL BACKGROUND WASH

As with tonal papers, working on top of a wash will help to harmonize your palette, as all the colors you use will be affected by the underlying tones of the wash. You can create a colored wash with watercolor pencils (see page 91), or you can experiment with the browns that tea, coffee, or even a stock cube will give you. This type of wash won't give you the uniform color of tonal paper, but this can be quite exciting, as you will get a greater variety of tones. Don't be afraid to let the color pool as it dries.

Creating your own wash, like Scott Altmann has done here, can give your background texture and tonal variations, which will add to the complexity and interest of your drawings.

TRY IT YOURSELF

1. A teabag wash is one of the easiest ways to create a tonal background. Start by squeezing a wet teabag over a sheet of paper.

2. Use a brush to move the tea around the sheet. Allow it to pool so it dries unevenly.

3. Once the tea has dried, you can draw on top.

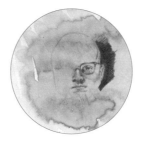

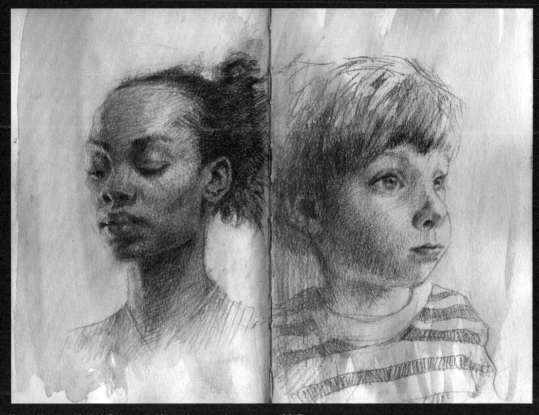

Scott Altmann, *Jade & Dylan*, graphite and watercolor on paper, 2015

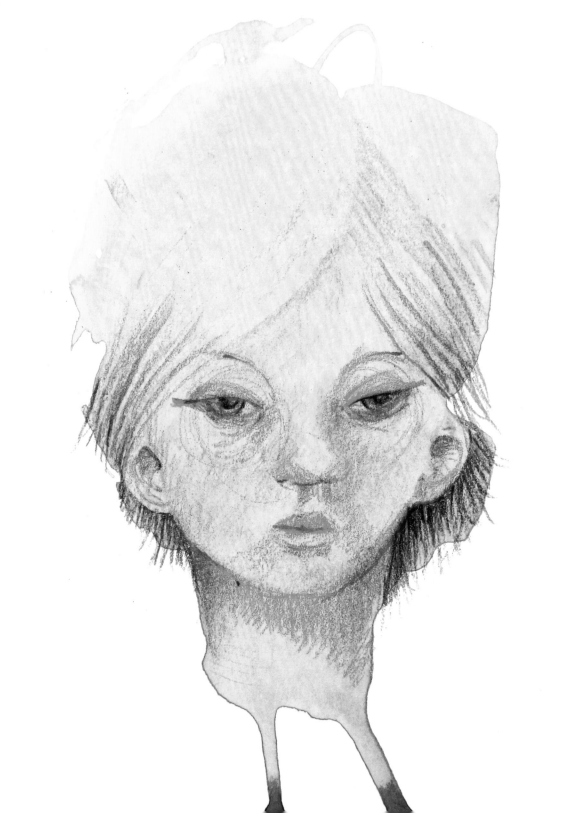

BE INSPIRED BY A SPLAT

Opposite:
Eve Blackwood,
Tea Lady, tea and
color pencil on
paper, 2021

Dropping a teabag onto your page is a great first step to making a background wash (see page 110). But before you spread the tea around, take a moment to look at the shapes created by the splatter and see if they inspire you to create a character or scene. In this example, you can see that the shape of a teabag splat was the inspiration for this drawing.

TRY IT YOURSELF

1. Drop a wet teabag onto your paper.

2. Tip the paper to encourage the tea to drip and create more interesting shapes.

3. Allow the paper to dry. Then work into the shape with color pencils to bring out a character or face. You could go on to make a whole series of characters.

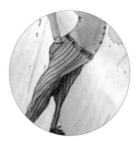

SKETCHBOOKS—YOUR SAFE PLACE

A sketchbook can be any book or collection of papers that you enjoy drawing in. Whatever size or shape it takes, your sketchbook is your safe place, a private space where there is no expected level of excellence that you have to meet. It is not a finished artwork – it is a place to experiment, to work things out, and most importantly to play! There are a variety of sketchbooks available to buy. Some are spiral bound, others are clothbound; some have heavier papers or papers that are suited to particular media like watercolor or pastels. Which size of sketchbook is best depends on what you want to use it for. A smaller sketchbook is good for taking outside to draw from life. But if you plan to work on bigger, more considered drawings, a larger pad with more robust paper might suit you better. You can also make your own sketchbook by fastening a variety of papers to a clipboard or piece of stiff card with a bulldog clip.

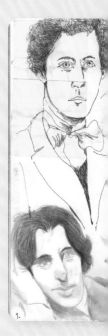

Spiral-bound

Pages are held together by a wire spiral threaded through holes punched in the paper. Normally hardback.
Pros: Opens out flat or flips over, so it is easy to lean on when standing or on the go.
Cons: The wire binding means that you can't work across the whole double page.

Perfect-bound

Pages are stapled or sewn in sections and then glued together. Available in hardback or softback.
Pros: Easier to work across the double page.
Cons: Can be harder to handle when drawing outside. If the sketchbook doesn't open out flat, it can be difficult to work close to the gutter.

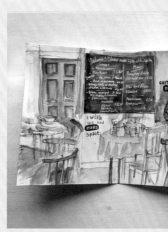

Improvised

Can be made in a variety of ways. Best to have a hard board to lean on.
Pros: Can be any size, any thickness, any paper you choose.
Cons: Easier to lose drawings.

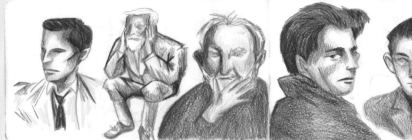

Left, above and below: Asimina Hollingworth

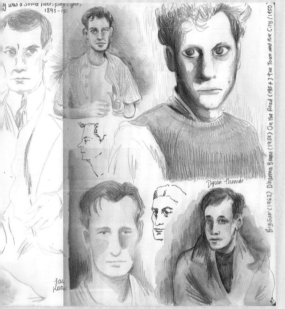

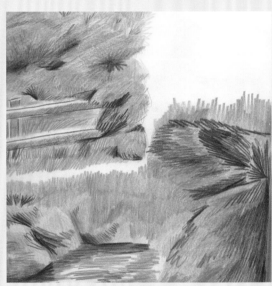

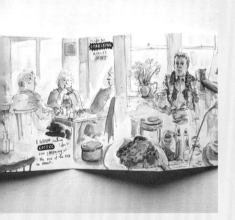

Above and right: Sophie Peanut

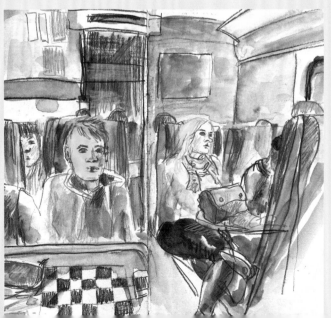

SKETCHBOOKS CONTINUED

All on this page:
Emma Carlisle

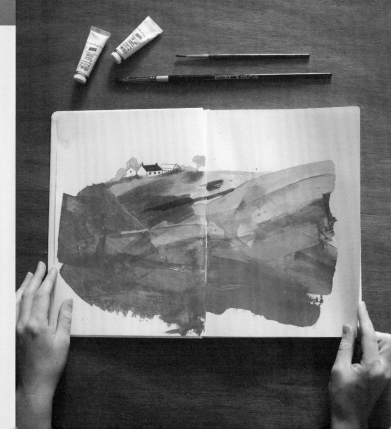

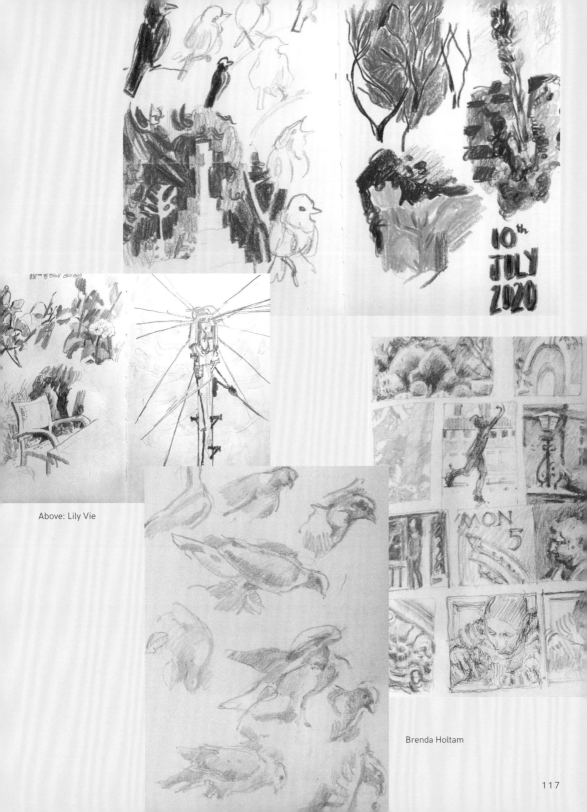

Above: Lily Vie

Brenda Holtam

117

ADAPT YOUR SKETCHBOOK

New sketchbooks can be daunting with lots of blank, white pages. Adding washes to random pages can make it less intimidating so that you're not always starting on a stark white page. If you do this in advance, it also means that you don't need to carry watercolors with you. You might also consider sticking interesting papers, labels, stamps, etc., on other pages to inspire you. Remember: you don't have to start at the beginning of a sketchbook and work doggedly through it, you can jump around using whichever pages you want to or turn the sketchbook upside down and work from the back towards the front.

TRY IT YOURSELF

Put washes on random pages
Create background washes in different colors with watercolor pencils or other materials such as tea (see pages 82 and 110).

Paste in images from newspapers and magazines
Experiment with collage to create different backgrounds or to add bold areas of color to your sketchbook pages (see pages 102–105).

Make splodges and splatters
Try splattering some paint or making teabag splodges to create silhouettes that you can adapt into something later (see page 112).

Add some different surfaces
Try sticking different types of paper into your sketchbook, such as tracing paper (see page 107) or tonal paper (see page 108).

MEET OUR CONTRIBUTORS

Alex Nicholson
www.alexnicholson.uk

Alex Nicholson is an illustrator from London. He studied at Norwich University of the Arts, and is interested in (among other things) the depiction of politics and contemporary events, using drawing as a tool of journalism. He is involved in the Topolski Studio residency, training young artists to use drawing to report on the world. His drawings and prints have been exhibited in the UK, Spain, and South Korea.

Andrea Serio
andreaserio.net

Andrea Serio's artworks are made by hand, mostly using oil pastels, wax pastels, and colored pencils. He has illustrated children's books, graphic novels, and affiches, and has designed covers for novels, magazines, and records. His drawings have been featured at national and international events. He is inspired by nature, particularly the mutable and ineffable relationship between light and shadow, which he enjoys trying to translate on paper.

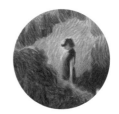

Asimina Hollingworth
@asimina_hollingworth

Asimina Hollingworth experiments with traditional and digital methods, using distinct lines and shapes to capture whimsical and playful visuals. Her work is derivative of comic book art and children's book illustrations. She aims to invoke an atmosphere of comedy and playfulness through exaggerating shapes and expressions.

Brenda Holtam
www.brendaholtam.com

Brenda Holtam is a figurative painter and a teacher. She works in oils, watercolor, gouache, and a wide range of drawing media. Brenda graduated from Falmouth School of Art and the Royal Academy Schools in the UK, and was elected a member of the Royal Watercolour Society. Her work is based on strong drawing skills and a fascination with color harmony.

Brooks Shane Salzwedel
www.brookssalzwedel.com

Brooks Shane Salzwedel graduated from the Art Center College of Design in Pasadena, California, in 2004. Since then he has exhibited in galleries and museums across the world, and has been an artist-in-residence in Denali National Park and Aspen. Most recently, his mixed-media works have focused on natural and man-made imagery specific to Los Angeles public parks.

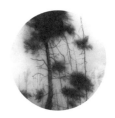

Claire Drury
@clairedruryart

A textile artist, ceramicist, and junior art teacher, Claire Drury strives to make every day creative. She collects treasure—feathers, old maps, fossils, broken pottery pieces—and is particularly interested in repurposing items discarded or unseen by others. This is reflected in her found objects pictures, quilts created from clothes, and ceramics decorated with imprinted surface design.

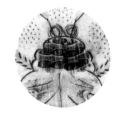

Emma Carlisle
www.emmacarlisle.com

Emma Carlisle is an artist and lecturer based in Plymouth, UK. Her work is primarily concerned with the landscape of Devon and Cornwall, a subject that allows her to revel in color and expressive marks in pencil, crayon, gouache, and acrylic. Emma creates drawings in sketchbooks on location, which she develops into large abstract paintings on canvas back in her studio.

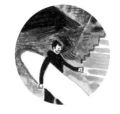

Endre Penovác
penovacendre.com

Born in 1956 in Serbia, Endre Penovác completed his education at the Academy of Arts at the University of Novi Sad. As an independent artist, he has been exhibiting his work across Europe for almost four decades. His paintings are inspired by the immediate world, themes that have become part of his signature style.

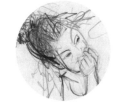

Jane Fisher
www.janefisherbotanicalart.com

Botanical art is the perfect intersection between Jane Fisher's lifelong interests in science and art. Although most botanical art is done in watercolor, she fell in love with graphite pencils in her first drawing class. Jane's work was included in the 2014 Royal Horticultural Society show in the UK and is in the permanent collection of the Hunt Institute for Botanical Documentation in Pittsburgh, Pennsylvania.

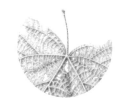

Jonathan Farr
jonathanfarr.com

Artist Jonathan Farr studied sculpture at the Slade School of Fine Art in London, but since graduating his work has been predominantly drawing. He illustrates children's books, paints from drawings, and draws from observation. His subject matter is three-dimensional space and the mood, atmosphere, figures, and light that inhabit it.

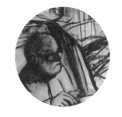

Leo Macdonald Oulds

Leo Macdonald Oulds graduated from the Royal Drawing School in London in 2021. He uses observational drawing to explore the sensation and emotion of both places and people. His exploration of printmaking and drawing is an attempt to simultaneously evoke both physical presence and the relationship between artist and sitter.

Lily Vie
www.lilyvie.com

Lily Vie is an illustrator and comic artist currently based in London. Using a combination of traditional and digital media, mainly watercolor and gouache, her work explores fantasy and the surreal, as well as the familiar and comforting. She draws inspiration from nature, ornamental design, typography, and little creatures.

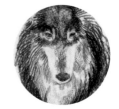

Lucia Vinti
luciavinti.com

Lucia Vinti is a London-based illustrator who makes work about people, places, food, and culture, drawing inspiration from the world around her. Working in pencil, pen, collage, and paint, Lucia creates joyful and colorful illustrations and hopes to encourage people to see the world in new and exciting ways. Her previous clients include Tate Britain, the NHS, and The Modern House.

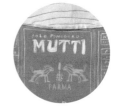

Lui Ferreyra
www.luiferreyra.com

Lui Ferreyra is a Mexican-born artist based in Denver, Colorado. His drawings and paintings focus on landscapes and the human figure, revolving around a signature style emphasizing the deconstruction of visual experience and its reconstitution. His work has been featured in publications including *New American Paintings*, *Wired*, *Fast Company*, *Forbes,* and *HuffPost*.

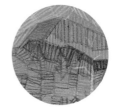

Marcus James
www.marcusjames.co.uk

Marcus James's work aims to demonstrate a process of control within a new visual language used to reassess the connections between landscape in art and our relationship to nature. He imposes a system of rhythmic, stylistic marks to articulate space in landscape. He creates a facsimile that has been processed through drawing, which reflects the human battle to dominate nature.

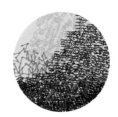

Massimo Rossetti
www.massimorossetti.com

Massimo Rossetti sees art as a conceptual detonator, an aesthetic tool that, by revealing our perceptual limits, feeds the inclusive terrain of action between us and others. Artwork becomes an equation with a subjective result, a flexible field for reconnecting humankind and techne. His work has been exhibited in solo and group exhibitions in Europe and the United States.

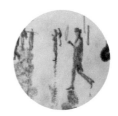

Morten Schelde
www.mortenschelde.com
Morton Schelde has worked with drawing since graduating from the Royal Danish Academy of Fine Arts in Copenhagen in 2001. In particular, he enjoys large drawings in which he meticulously develops spaces that form dream-like scenarios. Though his drawings are often very detailed he never plans too much, preferring to keep the work as spontaneous and direct as possible.

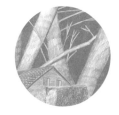

Peony Gent
www.peonygent.com
Peony Gent is an illustrator, comics maker and poet based in London. Her work is based in experimentation and a love of observational drawing, using a quick and loose hand to capture the essence of a subject. Her work aims to celebrate the purity and joy of everyday objects and experiences, both through storytelling and a stylized celebration of form.

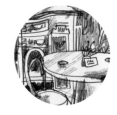

Rachel Mercer
www.rachelmercerartist.com
Rachel Mercer studied at the Royal Drawing School, and since graduating in 2013 has been a practicing artist and art educator in London. She is primarily an oil painter, but observational drawing is integral to her studio work. Her paintings are largely autobiographical. She exhibited her work in China in 2018 and regularly participates in London shows.

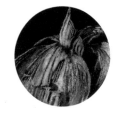

Scott Altmann
scottaltmannart.com
Scott has been a professional illustrator for more than 15 years, with clients including publishers such as HarperCollins, Random House, and Penguin Books, as well as Firstborn, Blizzard Entertainment, and Gates Co. Scott has turned his focus on his personal paintings with a renewed intent and vision, searching for hopeful moments of clarity in the vague transitions of existence.

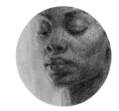

Sophie Peanut
sophiepeanut.com
Sophie Peanut is an artist, illustrator and art teacher who works in a range of media, including pencil, watercolor, fineliner, and digital. She likes to draw quickly, often from life, and she is interested in capturing impressions, feelings, and moments in time. Her drawings and illustrations carry a strong storytelling element and often include hand lettering.

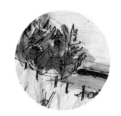

Wilfrid Wood
@wilfridwoodsculptor
Wilfrid Wood started off working on the satirical TV puppet show *Spitting Image*. He now draws and sculpts portraits of friends, celebrities, oddities, and pets.

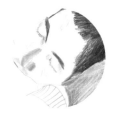

GLOSSARY

atmospheric perspective a visual phenomenon where objects further away appear fainter and blueish due to the density of air between the viewer and the object.

belly the part of a brush below the tip. The belly is the reservoir of the brush, where the paint or water is held.

blending stump (tortillon) a tightly rolled tube of paper with a tapered end used to blend graphite and charcoal to achieve smooth gradations.

blender pencil a soft colorless pencil that allows you to soften pencil strokes. It smooths and blends both graphite and color pencils.

collage a picture created from pieces of paper, photographs, fabric, and other printed things stuck down onto a surface.

color palette the selection of colors that you use in a painting or drawing.

complementary colors two colors that sit opposite each other on the color wheel. When placed next to one another in an image they enhance each other.

dry blending a watercolor pencil technique that involves combining two or more colors on a page before water is added.

fixative an aerosol that is sprayed onto the surface of a graphite or charcoal drawing to stop it smudging.

format the shape of a sheet of paper or a drawing. If it is taller than it is wide, it is in portrait format; if it is wider than it is tall, it is in landscape format.

frottage a technique for making an impression by rubbing graphite over a piece of paper that is placed on top of an object.

gradation the smooth transition from a dark tone to a light tone or vice versa.

graphite a gray shiny mineral used in pencils. Clay is added to the graphite to make it harder. H pencils have more clay and are quite hard; B pencils have more graphite, which means they're softer and therefore darker.

GSM grams per square meter—how the weight of paper is measured. The higher the GSM, the thicker the paper. Paper can also be measured in pounds per ream (lb).

highlights the lightest areas of a drawing, usually representing where light strikes or reflects off an object or surface.

lifting out creating a lighter area of tone. In watercolor pencil washes, this is done by removing some of the pigment with a clean, damp brush or a tissue. In graphite or charcoal drawings, you can do this with an eraser.

medium (pl. media) material used by an artist. A mixed-media drawing uses multiple materials.

monochrome a drawing that is composed of different tones of a single color.

monoprinting a form of printmaking that allows for only a single transfer of an image, unlike most printmaking, which allows for multiple transfers.

negative space the empty or open space around an object.

optical mixing a phenomenon in which small marks made in two separate colors appear to mix to create a new color as the viewer looks at them.

pigment the raw color that is used to make color pencils and paints. The more pigment, the more intense the color.

shading adding tone to a drawing to give the illusion of three dimensions, or to add atmosphere or mood (common shading techniques are hatching and cross-hatching).

tonal paper a colored paper on which you can draw. The color of the paper will affect the color of the pencils you use to draw on it.

tone the light and shadow that gives drawings a sense of form and depth, often described as light, mid, or dark. A tonal drawing is concerned with conveying light and shadow rather than outlines.

tooth the roughness of the surface of a paper. The rougher the surface, the more tooth it has.

tracing paper a translucent paper that is traditionally used to transfer a drawing from one surface to another, but can also be used to draw on.

wash a semi-transparent layer of paint. In washes created with watercolor pencils, the more water that is added to the pigment, the more transparent the wash becomes.

watercolor paper thicker, heavier-weight paper that doesn't buckle when water and washes are used on it. Can have a smooth or rough texture.

INDEX

Page numbers in *italics* indicate illustration captions.

PICTURE CREDITS

ACKNOWLEDGMENTS

Thanks to Donald Dinwiddie, Zara Larcombe, Gaynor Sermon, and Andrew Roff, who have all spent time at the helm, steering us through muddy waters, and to Peter Kent, who sadly passed away while working with us.

Thanks and love to Ian, Rowan, and Gil, without whom this would be meaningless; and to Selwyn, what a treat to get to write a book with such a treasured friend. This book is dedicated to June Humphrey and to Eve's mother, who saw the beginning but not the end of this journey.

ABOUT THE AUTHORS

Eve Blackwood is a Scottish artist and educator who lives in London. She has worked as an illustrator, independent filmmaker, printmaker, and BBC editor, and is currently an art teacher. She draws every day and aims to inspire others to do the same.

Selwyn Leamy is an artist who lives and works in London. He has experience in teaching a broad range of ages and, as a co-founder of the creative travel company Frui, has taught drawing and painting in various beautiful locations around the world. He has exhibited his landscape paintings extensively in the UK and also in Italy.